IMAGES
of America

HOPE CEMETERY

IMAGES
of America

HOPE CEMETERY

Zachary T. Washburn
and Linda N. Hixon

ARCADIA
PUBLISHING

Published by Arcadia Publishing
Charleston, South Carolina

Printed in the United States of America

Library of Congress Control Number: 2017962584

For all general information, please contact Arcadia Publishing:
Telephone 843-853-2070
Fax 843-853-0044
E-mail sales@arcadiapublishing.com
For customer service and orders:
Toll-Free 1-888-313-2665

Visit us on the Internet at www.arcadiapublishing.com

CONTENTS

ACKNOWLEDGMENTS

Hope Cemetery is a place that both authors feel is an important aspect to the city of Worcester's history. As the only city-owned cemetery still in operation, Hope is the final resting place of the rich, the poor, and everyone in between. We first thank the Friends of Hope Cemetery for supporting our project, sharing information, and allowing the use of several of their photographs. We also thank William Wallace and the Worcester Historical Museum for generously allowing the use of their collection. We thank Sari Bitticks and the Auburn Historical Museum for sharing photographs and offering advice. Lorice Swydan and Fr. Milad Selim at St. George's Orthodox Cathedral and Stuart Drake and Charlie Labonte at All Saints Church graciously allowed us to comb through their archives and use many of their images.

Our sincerest gratitude to Maryanne Hammond who donated the use of several pictures and offered many more. We also thank Tristan Hixon and Quintin Lapolito for their tireless efforts in finding suitable images.

Many other individuals contributed their collections to this project, including Frank Morrill, Timothy Rucho, Thomas Tashjian, Gregory Steffon, Fr. Timothy Lowe, Bob Laska, Julian Peci, Paul Swydan, John Anderson, Ann "Cookie" Nelson, Sally Talbot, and Joy Hennig. Several institutions are owed thanks, including the Worcester Public Library, American Antiquarian Society, Massachusetts Military Museum, and the Chapin Library at Williams College.

Wendy Maynard and Stephanie Choquette in the Hope office were instrumental in locating graves and providing lot cards for most of the people written about in this book.

Unless otherwise stated, all images are courtesy of the authors.

INTRODUCTION

Whether out of fear or foresight, the City of Worcester decided in 1852 that a new public cemetery was needed. Worcester had just become a city in 1848, and its population had more than doubled between 1840 and 1850 to over 17,000. The downtown burial grounds were becoming full, and the fear of disease and contamination from decomposing bodies spurred the idea. But so did the massive growth of the city. Worcester was well on its way to becoming an industrial powerhouse, with a bustling railroad system linking the city to Boston and Providence, Rhode Island.

Regardless of the reason, land was purchased by the City of Worcester in what was then called New Worcester, an area on the outskirts of the city near the town of Auburn. This area replaced several earlier burial grounds, including the Mechanic Street Burying Ground and the burial ground at the Worcester Common, which were mostly in the growing downtown area. Hope Cemetery, now over 160 years old, is the only city-owned cemetery still in operation today. The story of Hope parallels the story of Worcester—it is a space of diversity, the final resting place of a cross-section of residents, from wealthy industrial leaders to those less fortunate, holding all races, nationalities, ethnicities, and religions in its 168 acres.

The following pages give the reader an insight not only into the history of Hope Cemetery, but also the history of Worcester, the second largest city in New England, through the lives of the interred. We begin with an introduction to the history of the cemetery, which became quite the discussion between the city's leaders and residents over the title of the new burial ground. The rural cemetery movement, of which Hope was a part, was an important influence on the layout of the grounds, with the granddaddy of the movement, Mount Auburn Cemetery, just a train ride away in Cambridge, Massachusetts.

As Worcester grew, so did the need for land in the downtown area. This necessitated the removal of both the Mechanic Street Burial Ground and those interred in the Worcester Common. While some bodies were removed to Worcester's Rural Cemetery, the majority were reburied within the walls of Hope Cemetery, with some resting in family lots and others in two sections discussed later. Also removed to Hope were the graves of Tatman Cemetery and Pine Meadow and Raccoon Plain Burial Grounds.

Chapter three focuses on two aspects of the physical layout and surprising beauty of Hope Cemetery. The first is a section dubbed the Land of the Giants, which has dozens of larger-than-life gravestones, many intricately carved and sculpted by master stone masons, and most have withstood the test of time. The second aspect is the actual "giants"—the industrialists and prominent citizens of Worcester society, many of whom are buried in that impressive section.

Worcester is extremely ethnically diverse, and nothing proves this more than the many ethnic sections within Hope. Calling Hope Cemetery their final resting place are such people as the first Swedish immigrant to call Worcester home and the first Chinese family to live and have children born in the city. But those people were merely the trailblazers—dozens of other ethnic and religious groups have made Hope their last address.

Hope honors the heroes of Worcester, those who served in the military, as well as the police and firemen and others who have put their lives on the line for their fellow man. Hope is the final resting place of people who served in every American war, and this book includes the stories of the men—and women—who served in the military as far back as the Revolutionary War. Men who died in the Civil War are buried in Hope, along with veterans—soldiers, sailors, marines, and even Civil War nurses. One organization discussed is the Grand Army of the Republic (GAR), George H. Ward Post 10, which is prominently represented throughout the cemetery, including in two GAR lots. Hope also houses those who served in both world wars, and wars right up through the present.

Chapter five finds the interesting stories of prominent and important citizens of the area, including doctors, politicians, judges, and scientists, but goes beyond those tales. This chapter also focuses on the regular citizens of Worcester, those good, everyday people who worked hard to shape Worcester into the second largest city in New England. But Worcester also had citizens who could be called notorious, like Webster Thayer, a prominent judge who was thrust into the national spotlight with the infamous Sacco and Vanzetti trial of the 1920s. On the other side of the courtroom is convicted murderer Charles Tucker, who was electrocuted—cutting-edge capital punishment in 1906. His was a controversial case, and he is buried in Hope in an unmarked site.

We also take a look at the fashion of the mortuary scene. How a grave is marked has changed over the nearly 200 years since Worcester was founded, and stones from every monument fashion can be found scattered throughout the cemetery. Hope has everything from the slate stones of the Puritans to the latest laser-cut black granite. The cemetery also boasts a large selection of blueish-gray gravestones, commonly called "white bronze," which are not actually stones at all. These trendy markers, along with intricate carvings and curious sayings, and some of the people who created these monuments, can be found in chapter six.

The final chapter deals with the struggles of a city cemetery in the 21st century and how the Friends of Hope Cemetery organization, founded in 1991, assists in the preservation, conservation, and beautification of Hope Cemetery. The Friends were instrumental in getting Hope Cemetery listed in the prestigious National Register of Historic Places and have raised money to help save important mausoleums and monuments within the cemetery grounds. Each year, the group holds events including walking tours, presentations, clean-up days, and memorial celebrations. The group also helped contribute to the information found in this book.

One

ANYTHING BUT "WILD WOOD"
THE HISTORY OF HOPE CEMETERY

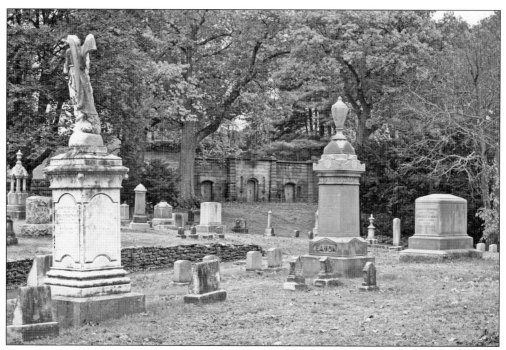

Shown in the distance, the receiving tomb was constructed in 1872 and replaced an earlier vault, which was built around the time the cemetery opened. While the location of the original vault is unknown, this vault is hidden on the backside of a hill. Local architectural firm Fuller & Delano was contracted for additions and improvements of the tomb in 1887.

Situated on over 160 acres, Hope Cemetery was dedicated in 1854 during the height of the rural cemetery movement. After two years of planning, the cemetery was placed at the outer city limits, and burials from areas closer to the city center were eventually moved to the new space. (Courtesy of the Worcester Public Library.)

Today, Hope is the democratic resting place for the people of a growing city. Any citizen of Worcester has the right to be buried in the cemetery, even if they are unable to pay. Hope is also the resting place of the great and the good from the history of a fast-growing industrial city, including the social elite, manufacturing giants, artists, scientists, activists, and regular citizens from every walk of life. (Courtesy of the Worcester Public Library.)

HOPE CEMETERY.

LOTS FOR SALE.

HAZEL AVENUE.		CEDAR AVENUE.	
NORTH SIDE.		NORTH SIDE.	
No.	PRICE.	No.	PRICE.
1061	$18	1329	30
		1332	30
		1341	32
MAGNOLIA AVE.			
NORTH SIDE.		**PINE AVENUE.**	
1128	40	NORTH SIDE.	
1129	40	1411	45
1133	40	1416	45
		1417	45
		1418	45
GLEN AVENUE.		1419	45
SOUTH SIDE.		1423	45
1290	22	1424	45
1303	22	1425	45
1304	20	1427	45

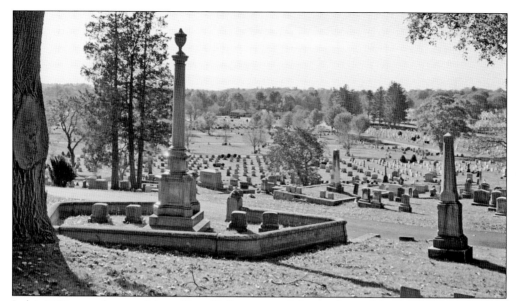

In his 1852 annual report, Mayor Peter C. Bacon noted the purchase of the property: "During the past year, the city has made a purchase of a lot of about 50 acres, situated south of New Worcester, for a public cemetery, at a cost of $1855." He also noted that "It is neither too remote from, nor too near to, the city. Its surface is variegated with hills and valleys. It is elevated above the New Worcester stream, which sweeps it upon the north."

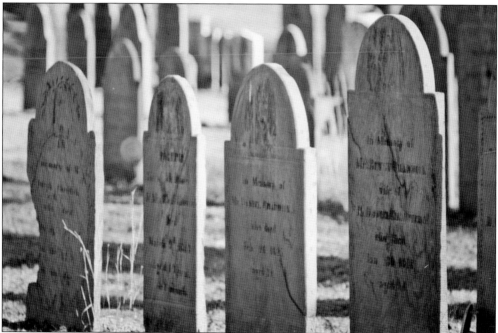

In the early 1800s, the science of medicine was in its infancy. A series of epidemics across the northeast in the 1820s led to a fear of cemeteries, a legitimate fear that corpses buried in populated areas caused illness, especially in growing town and urban areas. This came out of the miasma theory, which held that disease spreads through "bad air." Local governments began to think about moving cemeteries out of town centers. (Courtesy of Tristan L. Hixon.)

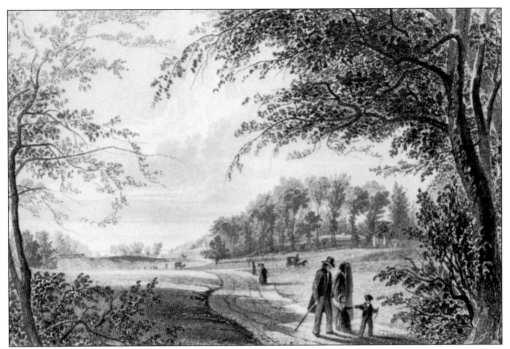

The first rural cemetery in the country was Mount Auburn Cemetery in Cambridge, Massachusetts, created in 1831. Rural cemeteries were not centered on religion, but were nondenominational. Based on the English Romantic movement, this growing cemetery movement set out to create places of refuge and relaxation in industrialized urban areas. Young people were encouraged to visit cemeteries to view monuments and learn about the rewards of hard work. (Courtesy of the Worcester Public Library.)

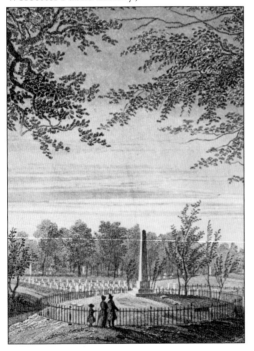

Many notables wrote about the beauty of this cemetery movement. Local woman's rights advocate Lydia Maria Child, a friend of Worcester and Hope Cemetery resident Abby Kelley Foster, saw the rural movement as necessary in her modern world: "So important do I consider cheerful association with death, that I wish to see our graveyards laid out with walks and trees and beautiful shrubs as places of promenade." (Courtesy of the Worcester Public Library.)

The Curtis Memorial Chapel was given to the city by Albert Curtis, a former cemetery commissioner, in 1891. The cornerstone for the chapel was laid in July 1890 in a ceremony attended by many prominent citizens, including Curtis, Mayor Francis Harrington, and Loring Coes, all of whom would later be interred in Hope.

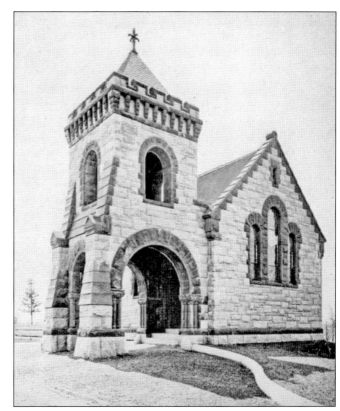

The chapel was a beautiful little stone building used for committal services, but by 1960, it was considered to be beyond repair, and the cemetery commission voted to demolish the building rather than repair it after two stones fell off the top. (From the collection of Worcester Historical Museum.)

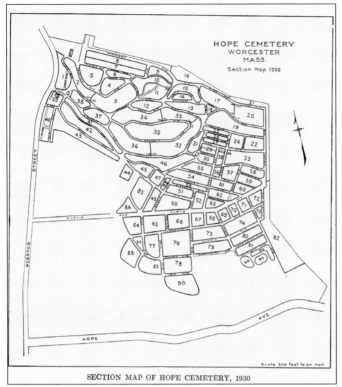

SECTION MAP OF HOPE CEMETERY, 1930

Hope Cemetery began as a small cemetery of about 50 acres, and while early maps of the cemetery no longer exist, this map from 1930 shows a continually expanding cemetery. It is believed that sections 10 and 11 may be the first areas developed. The office building was located on the northwest edge of the cemetery, and was built in 1882. In 1889, the office building was enlarged, and a stick-style barn was constructed. The superintendent's house is pictured below. (Both, courtesy of Hope Cemetery.)

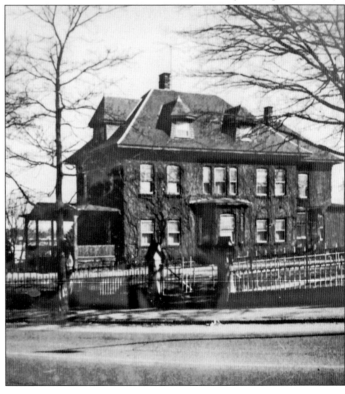

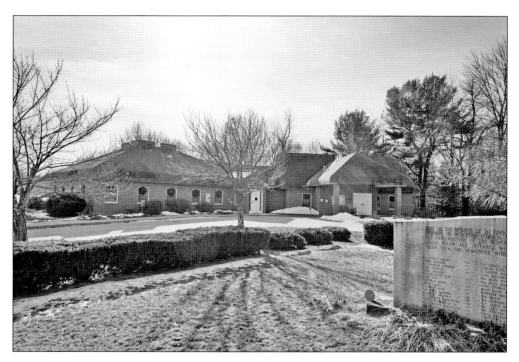

In the early 2000s, a new office and chapel was built on the southwest corner of the cemetery, replacing the old office. The new administration building was named in honor of Mario V. Zona, who served on the Hope Cemetery Commission from 1991 to 2001. The hall was named for Garabed Hovhanesian, who was serving as vice chairman and secretary of the Hope Cemetery Commission at the time of his death in 2001.

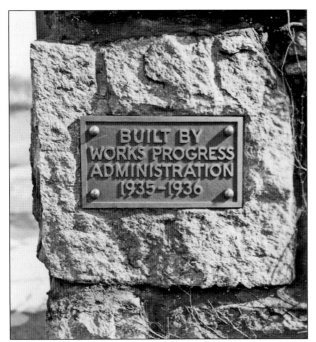

Almost the entirety of Hope's border with Webster Street is a stone wall. It was built in 1935–1936 by the Works Progress Administration (WPA), a program that came out of Pres. Franklin Roosevelt's New Deal. From 1935 to 1943, the WPA carried out public works projects by employing millions of people, including unskilled workers. (From the collection of Worcester Historical Museum.)

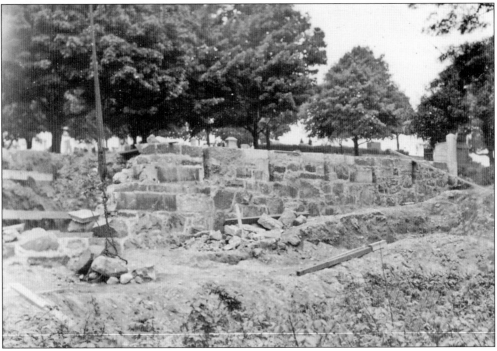

This photograph shows a portion of the wall mid-construction. Most of the granite used in WPA projects in the Worcester district was taken from the WPA Green Hill Quarry, where workers cut and shaped the stones used for buildings, curbings, and walls. Other WPA projects in the city include the renovation of the Quinsigamond Elementary School in 1936, along with repairing the 81 bridges in Worcester County that were destroyed by a flood in 1936. (From the collection of Worcester Historical Museum.)

Today, this stone column engraved with "Hope Cemetery 1936" sits at the main entrance to the cemetery. The WPA work at Hope was impressive, and in a meeting of New England cemetery officials in 1937, Hope superintendent Oscar Burbank gave a talk with a motion picture presentation of the completed work. (Both, from the collection of Worcester Historical Museum.)

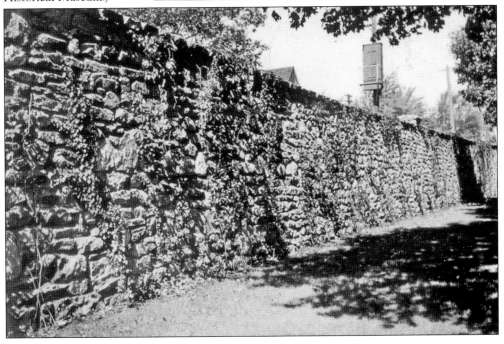

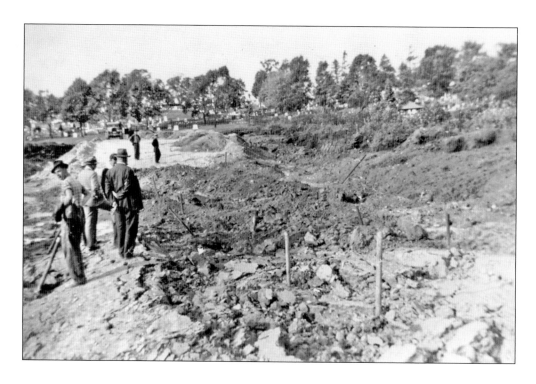

Cemetery workers were always kept busy with a multitude of projects, from digging the graves to cemetery cleanup and everything in between. These photographs from 1939 appear to show men working on grading a new section or possibly constructing a road to future sections of the cemetery. (Both, from the collection of Worcester Historical Museum.)

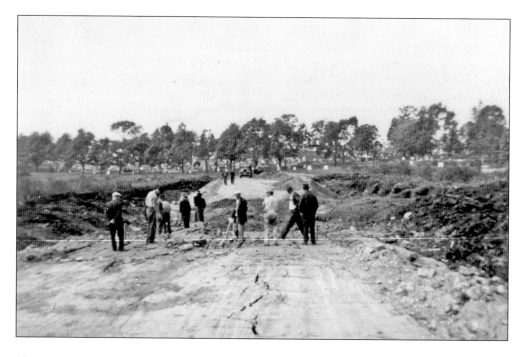

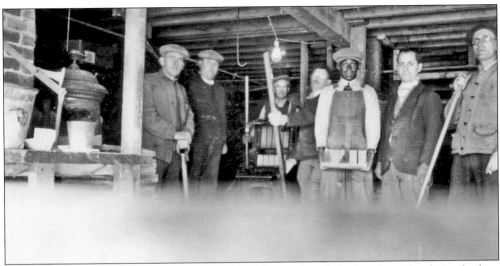

During the period when one office building was being demolished and another being built, a stash of photographs documenting the history of Hope Cemetery was found. The photographs, old and fragile, had little documentation but showed a snapshot of a space that was undergoing rapid change. Filled with the faces of those who are now probably gone, these two images show Hope's workers. The timeframe could be the 1930s. The men above, a mix of races and ethnicities, stand in what appears to be the lower level of the cemetery's barn getting ready for the day's work. Many of them are wearing shirts and neckties under their cold-weather sweaters. The solitary worker below is filling the pneumatic tire on a cart holding a plain wooden coffin for the dead. (Both, from the collection of Worcester Historical Museum.)

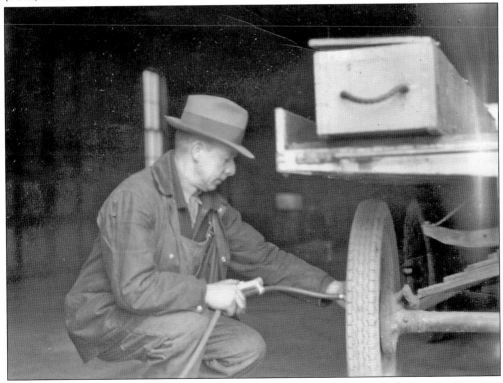

When downtown Worcester began growing, the city realized the need to relocate the burial grounds away from the center. With Hope Cemetery being city owned, it only made sense to remove those buried in the old rundown burial grounds and reinter them within Hope. This is the reason many gravestones predate the founding of the cemetery, with many slate stones dating from the early 18th century. (Courtesy of the Worcester Public Library.)

Plan of Mechanic Street Burial Ground, Oct. 2, 1798.

For Negro people.

Tomb of Isaiah Thomas ■

Reserved for Strangers and those who are not inhabitants of Worcester.

Through the kindness of Rev. George Allen, we have learned the names of the original owners to the following lots, as annexed in the margin:

1.—Isaac Putnam.
3.—Benjamin Thaxter.
3.—D. Blair.
5.—P. Slater.
7.—Nathan Heard.
9.—Samuel Warden.
11.—Levi Lincoln.
13.—Leonard Worcester.
15.—H. Sikes.
 S. Rice.
17.—George Merriam.
19.—Jonathan Lovell.
21.—John Green.
43.—Isaiah Thomas.
 Mrs. Fowle.
45.—Phineas Heywood.
 Nathaniel Paine.
47.—Nathaniel Chandler.
49.—Jacob Miller.
51.—William Caldwell.
53.—Joseph Allen.
55.—James McFarland.
57.—Joshua Whitney.
59.—Daniel Smith.
61.—Levi Flagg.
91.—John Gates.
93.—Samuel Rice.
95.—Francis Blake.
97.—Miles Sprague.
99.—Samuel Johnson.
104.—John Ranks.
103.—David Flagg.
105.—Joshua Harrington.
107.—Noah Harrington.

North 22½ East · ENTRANCE ON MECHANIC ST.

218	174	130	86	85								
216	172	128	84	42			41					
214	170	126	82	40			39	81	83			
212	168	124	80	38			37	79	123	167		
210	166	122	78	36			35	77	121	165	209	
208	164	120	76	34			33	75	119	163	207	
206	162	118	74	32			31	73	117	161	205	
204	160	116	72	30			29	71	115	159	203	
202	158	114	70	28			27	69	113	157	201	
200	156	112	68	26			25	67	111	155	199	
198	154	110	66	24			23	65	109	153	197	
196	152	108	64	22			21	63	107	151	195	
194	150	106	62	20			19	61	105	149	193	228
192	148	104	60	18			17	59	103	147	191	227
190	146	102	58	16			15	57	101	145	189	226
188	144	100	56	14			13	55	99	143	187	225
186	142	98	54	12			11	53	97	141	185	224
184	140	96	52	10			9	51	95	139	183	223
182	138	94	50	8			7	49	93	137	181	222
180	136	92	48	6			5	47	91	135	179	221
178	134	90	46	4			3	45	89	133	177	220
176	132	88	44	2			1	43	87	131	175	219

In 1795, Mechanic Street Burial Ground was opened as Worcester's third cemetery. It was frequently used until 1830 when interments decreased, with the last burial taking place in 1859. About 20 years later, the once small town of Worcester was now a sprawling city that needed more land to build on. It was decided that the neglected burial ground would be the site of expansion, and the 1,116 remains were ordered to be exhumed and buried elsewhere.

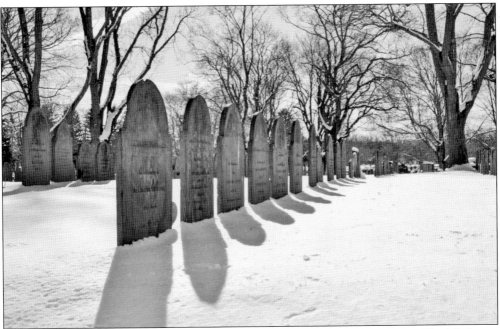

Some of the remains were reburied in Rural Cemetery, but most ended up in Hope. The Mechanic Street lot at Hope has 232 marked graves, and several unmarked graves holding remains that could not be identified. Graves in this lot are accompanied by original slate stones that show the popular decorations of the 18th and 19th centuries, with the most popular symbols being the urn and willow engravings. There are also several removals from Mechanic Street scattered throughout the cemetery, some with their original slate stones, and some with modern replacements. (Both, courtesy of Maryanne Hammond.)

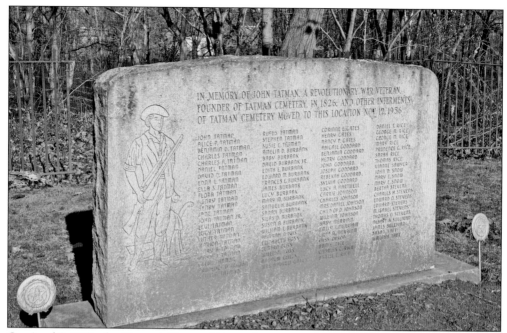

IN MEMORY OF JOHN TATMAN, A REVOLUTIONARY WAR VETERAN,
FOUNDER OF TATMAN CEMETERY, IN 1826; AND OTHER INTERMENTS
OF TATMAN CEMETERY MOVED TO THIS LOCATION NOV 12, 1956

On April 9, 1951, the General Court of Massachusetts approved an act authorizing the City of Worcester to take over the Tatman Cemetery on Greenwood Street for the purpose of a public park. This act forced the remains of those interred, including those of Revolutionary and Civil War dead, to be relocated to Hope Cemetery.

The founder of the cemetery, John Tatman, was a Revolutionary War veteran descended from some of the earliest settlers of Worcester. In 1826, he set apart the land to be used as a cemetery; prior to then, the Tatmans were buried in the east end of the Worcester Common.

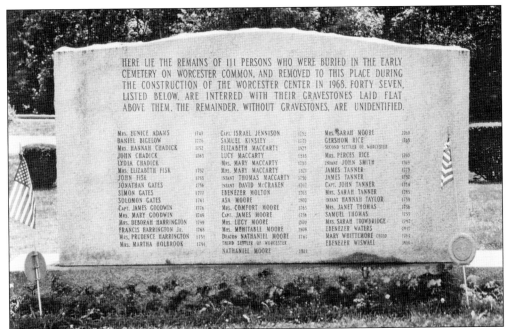

HERE LIE THE REMAINS OF 111 PERSONS WHO WERE BURIED IN THE EARLY
CEMETERY ON WORCESTER COMMON, AND REMOVED TO THIS PLACE DURING
THE CONSTRUCTION OF THE WORCESTER CENTER IN 1968. FORTY SEVEN,
LISTED BELOW, ARE INTERRED WITH THEIR GRAVESTONES LAID FLAT
ABOVE THEM. THE REMAINDER, WITHOUT GRAVESTONES, ARE UNIDENTIFIED.

Mrs. EUNICE ADAMS	1747	Capt. ISRAEL JENNISON	1752	Mrs. SARAH MOORE	1760
DANIEL BIGELOW	1776	SAMUEL KINSLEY	1773	GERSHOM RICE	1768
Mrs. HANNAH CHADICK	1752	ELIZABETH MACCARTY	1829	SECOND SETTLER OF WORCESTER	
JOHN CHADICK	1761	LUCY MACCARTY	1535	Mrs. PERCES RICE	1760
LYDIA CHADICK		Mrs. MARY MACCARTY	1735	INFANT JOHN SMITH	1769
Mrs. ELIZABETH FISK	1752	Mrs. MARY MACCARTY	1621	JAMES TANNER	1773
JOHN FISK	1755	INFANT THOMAS MACCARTY	1756	JAMES TANNER	1752
JONATHAN GATES	1756	INFANT DAVID McCRAKEN	1762	Capt. JOHN TANNER	1754
SIMON GATES	1717	EBENEZER MOLTON	1763	Mrs. SARAH TANNER	1285
SOLOMON GATES	1761	ASA MOORE	1800	INFANT HANNAH TAYLOR	1759
Capt. JAMES GOODWIN	1776	Mrs. COMFORT MOORE	1765	Mrs. JANET THOMAS	1758
Mrs. MARY GOODWIN	1749	Capt. JAMES MOORE	1756	SAMUEL THOMAS	1755
Mrs. DEBORAH HARRINGTON	1799	Mrs. LUCY MOORE	1500	Mrs. SARAH TROWBRIDGE	1757
FRANCIS HARRINGTON Jr.	1765	Mrs. MEHITABLE MOORE	1609	EBENEZER WATERS	1815
Mrs. PRUDENCE HARRINGTON	1751	DEACON NATHANIEL MOORE	1761	MARY WHITTEMORE CHILD	1734
Mrs. MARTHA HOLBROOK	1791	THIRD SETTLER OF WORCESTER		EBENEZER WISWALL	1800
		NATHANIEL MOORE	1811		

In 1968, Worcester had the remains of 111 early residents removed from the Common burial ground and reinterred into a lot in Hope Cemetery. This lot near the present office and chapel lists the 47 names of those who were reburied there, including Gershom Rice, the second settler of Worcester. The remaining 64 removals are unidentified, as there were no stones found to identify the remains. (Courtesy of the Friends of Hope Cemetery.)

The stone belonging to Isaac Glezen is probably one of the oldest gravestones in Hope. Isaac died in January 1776, and was originally buried in the Common. His body was exhumed in 1902 and reburied in Hope near several generations of his descendants. The blue slate headstone was found buried four feet under the Common, and is now perched atop one of the large rolling hills of the cemetery.

23

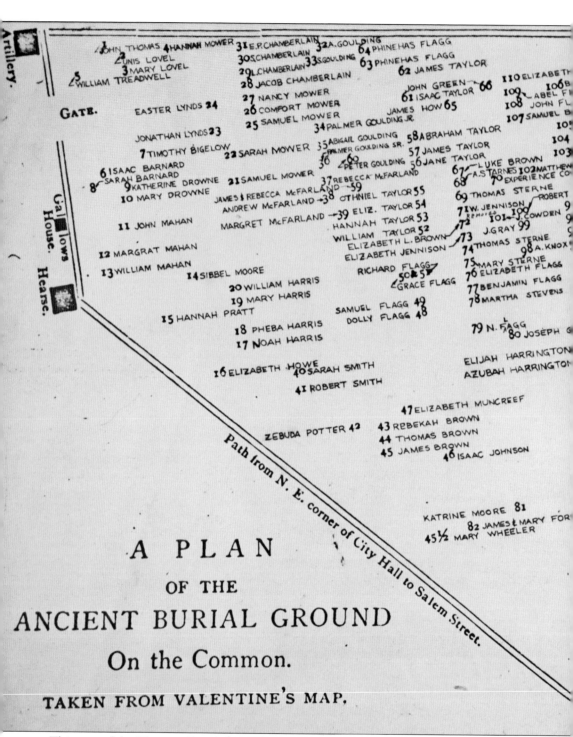

A PLAN

OF THE

ANCIENT BURIAL GROUND

On the Common.

TAKEN FROM VALENTINE'S MAP.

This map of the "Ancient Burial Ground" on the Worcester Common shows the layout of the old cemetery. Many of the surnames found on this map have been incorporated into Worcester's history by way of street names. Today, only a small fenced section of the cemetery remains, marked by a large monument erected in 1861 honoring Timothy Bigelow, a patriot in the American

Wheeler Tomb. Dix Tomb. Chandler Tomb.

LAIR McFARLAND
IR BARBER
RT BARBER
Y BARBER
MARY BARBER
THAN RICE
THA BARBER
N RICE
H RICE
BBARD
19 MARY BARBER
ROTHY HUBBARD
20 JAMES BARBER
RICE'S CHILDREN
NNAH HUBBARD
RICE
AMIR IS STEVENS
123 ZEPHANIA RICE
124 C. ADAMS
DOROTHY CHAPIN
126 JOHN MACKAY
JONES 127
BEKAH CURTIS 142
140 SUSANNA CURTIS
139 JOHN CURTIS
138 DOLLY F. CURTIS
137 ISAAC GLESEN (REMOVED)
M. RICE
128 JOHN KNIGHT
6 E. RICE
ESTHER ELDER 136
MARY BOYDEN 135
134 ESTHER ELDER
LA GROUT
EBECCA MOORE
129 REBEKAH JONES
130 NOAH JONES
MARY WALKER 133 WILLIAM ELDER
132 MARGRAT HAMBLETON
131 ELIZABETH THOMAS
DAVID McCRAKEN 171

150
SAMUEL MILLER
DAVID YOUNG 155
148 JOHN YOUNG 156
JOHN TAYLOR
CAPT. JOHN TANNER 181
146 EPHRAIM ROPER 158
SAMUEL CLARK PAINE
145 NATHANIEL CURTIS
159 GERSHOM RICE 177 DANIEL WARD
160 LT. GERSHOM RICE
143 ELIZABETH CURTIS 161 ESTHER RICE
144 WILLIAM SWAN
141 CAPT. JOHN CURTIS

152 ABEL HAYWOOD
153 154 SAMUEL JR. HUNT
SAMUEL E. HUNT
ELIZABETH MACCARTY
DANIEL HAYWOOD JR. 182 JOSIAH PERRY
HANNAH HAYWOOD
157 MAJ. DANIEL HAYWOOD
158 JAMES TANNER 180
JAMES TANNER 179
SARAH TANNER 178
JONATHAN GATES 200

CORNELIUS STOWELL 185
SAMUEL STOWELL 184
NATHAN PERRY JR 183

MARY HAYWOOD

176 THOMAS NICHOLS

162 ABEL STOWELL
163 RELIEF STOWELL
164 JOHN JENNISON
165 FAITH JENNISON
166 175 IRENA WISWALL
167 174 EBENEZER WISWALL
ISRAEL JENNISON
168 ELIZABETH JENNISON 173 JOHN SMITH
169 ABIGAIL JENNISON
170 SAMUEL JENNISON

172 LORING SPRAGUE

186 MARY MACCARTY
187 EXPERIENCE MACCARTY 230 EBENEZER MOLTON
188 193 ASA MOORE REV. T. MACCARTY 229 JOHN CHADICK 231 EBENEZER WATERS
189 194 LUCY MOORE
MARY MACCARTY
LUCY MACCARTY 228 LYDIA CHADICK
190 195 COMFORT MOORE
227 ELIZABETH FISK
191 226 JOHN FISK
196 CAPT. JAMES MOORE 225 HANNAH CHADICK
192 THOMAS MACCARTY 222 FRANCIS HARRINGTON JR.
SARAH MOORE 221 PRUDENCE HARRINGTON
197 FRANCIS HARRINGTON
220 224 DEBORAH HARRINGTON
198 PERSIS MOORE 219 EUNICE ADAMS
218 MARY WHITTEMORE 223 AMOS HOLBROOK
199 ? 217 MARY ADAMS
201 SOLOMON GATES
202 ? 216 LYDIA HOLBROOK
203 JOSEPH WILEY 215 MARTHA HOLBROOK
204 JANET THOMAS
208 SARAH TROWBRIDGE
205 SAMUEL THOMAS 214 MARY GOODWIN
207 DANIEL BIGELOW
206 MARTHA WILEY 213 JAMES GOODWIN
209 SIMON GATES
210 DEA. NATHANIEL MOOR
211 MEHITABLE MOOR
212 NATHANIEL MOOR

SALEM STREET.

OLD COMMON SCHOOL HOUSE.

Revolution who was the colonel of the 15th Massachusetts Regiment of the Continental Army. He is also the namesake for the Col. Timothy Bigelow Chapter of the Daughters of the American Revolution in the city. (Courtesy of the Colonel Timothy Bigelow Chapter of the Daughters of the American Revolution.)

Hope Cemetery also holds the removals from other smaller burial grounds that were forced to move, including Raccoon Plain and Pine Meadow. Unlike the Common and Mechanic Street removals, remains from these cemeteries are scattered throughout Hope; unless the name of a person is known, the graves are difficult to find.

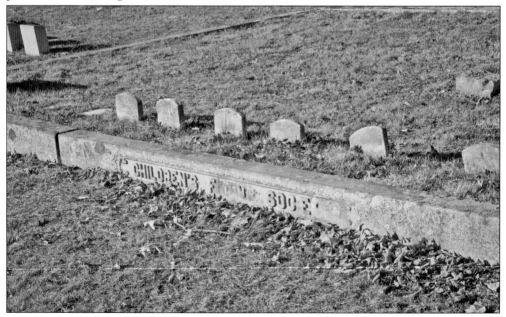

Found in the middle of a hilly section of Hope is the Children's Friends Society's lot where 14 children removed from Pine Meadow are buried. The stones have unfortunately weathered and are almost unreadable. The largest stone belongs to Tamerson White, matron of the orphan's home, who was involved with the society from its start in 1848 to her death in 1885 at the age of 71.

Two

THE LAND OF GIANTS

LARGER THAN LIFE MONUMENTS

By 1855, Worcester's population was 22,284, a number poised to increase. The Industrial Revolution was about to hit Worcester with a vengeance, in part because of local industrialists. By 1897, Worcester's population was 106,000, with the city producing some of the greatest varieties of goods in the entire country, including boots. A granite chapel was erected in Hope in honor of boot manufacturing giant Charles C. Houghton in 1903. (Courtesy of the City of Worcester.)

984 GRANITE.

ARTHUR O. KNIGHT, Sec'y and Treas.

TROY WHITE GRANITE CO.

Office, 10 East Worcester St.

Telephone No. 520. Warerooms, 71 Shrewsbury St.

HOUGHTON MAUSOLEUM, IN HOPE CEMETERY.

Monuments, Mausoleums and Tombs.

Write us for prices in rough stock or Finished Work. We make a specialty of Troy White.

Albert Curtis began his industry when Worcester was just a town. He started manufacturing cloth-finishing machines in 1831, and joined forces with Edwin Marble in 1845, creating the Curtis & Marble Machine Company. The company originally stood in New Worcester on Webster Street, not far from where Hope Cemetery would be founded just a few years later. The business later grew so large that a new plant was built on Cambridge Street.

Born in 1807, Albert Curtis was apprenticed in the woolen machinery business as a young man. He later specialized in shearing machinery and built the first machines for shearing cotton cloth in the United States, which were used to remove fuzz from cotton cloth. His house was in New Worcester near the Auburn town line, and he donated the land for the expansion of Hope Cemetery. (Courtesy of Worcester Public Library.)

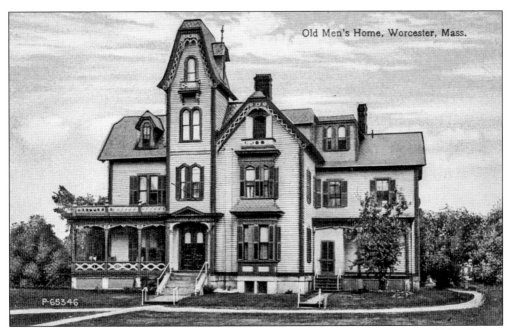

P·65346

Albert Curtis was a beneficent man, giving his wealth so those who had less could live better. In 1874, he donated an estate in New Worcester to be used as a home for old men. But there was a problem—Curtis had not given quite enough funds for the directors to use the property for its intended purpose, at least not at first. (Courtesy of the American Antiquarian Society.)

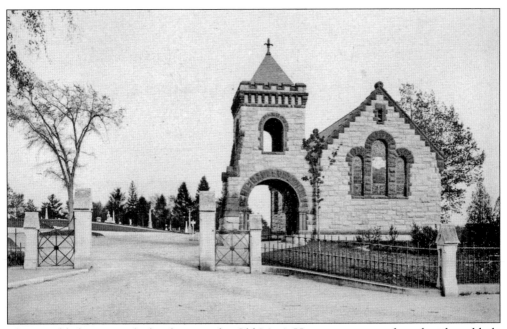

That would change, and what became the Old Men's Home went on to furnish aid to elderly men in need of assistance. A plot in Hope was purchased as a final resting place for some of these men. Albert Curtis himself died at 91, but not of old age—a gas jet was left on in his room, and he asphyxiated.

Even though he served as director of the Worcester Free Public Library, Edwin Tyler Marble was not born in the city. A native of Sutton, Massachusetts, Marble attended the Worcester County Manual Training School and then the prestigious Worcester Academy. He apprenticed as a machinist in Albert Curtis's shop, later forming a partnership with Curtis with the Curtis and Marble Machine Company.

Public Library, Worcester, Mass.

Edwin Marble's wife, Harriet H. Chase, became a teacher in the Worcester Public Schools, an important job in an educationally-based city like Worcester. Their son Edwin Henry Marble worked in the Curtis and Marble shop, learning drafting and engineering and earning himself an entry in *Who's Who in Engineering from 1922–23.*

Born in Rochester, New York, Charles H. Morgan began working in factories as a boy of 12. But like his father, he was mechanically inclined, learning mechanical drawing and chemistry while working for his uncle at the Clinton Mills dye house. Morgan later started his own company, making paper bags in Philadelphia with his brother Francis. A move to Worcester led to a supervisory position at Washburn and Moen Manufacturing Company.

Charles Morgan became a leading inventor and industrialist. His contributions included creating machinery for the steel industry, but he also designed the first hydraulic elevator in New England. He held many patents, and it was estimated that Morgan equipment was used in more than half of the world's rod mills. In 1898, the company looked to the future of gasoline engines, claiming it would soon sell a full line of sizes.

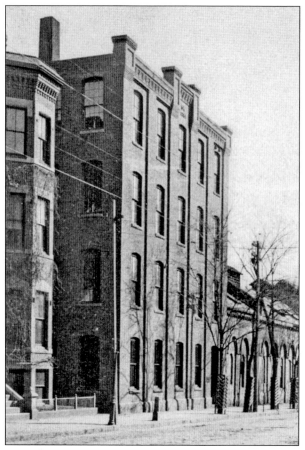

Charles Morgan began two companies, the Morgan Spring Company and the Morgan Construction Company, bought by Siemans in 2008. He and his wife, Harriet, were civically-minded—he was the director of the YMCA, and she was the president of the YWCA. During Harriet's tenure, the YWCA facilities, both restaurant and dormitory, were very popular. About 600 people registered for classes, and the organization had about 1,500 members. The philanthropic foundation of Morgan Construction Company recently made a donation to Worcester Polytechnic Institute, creating the Morgan Center for Teaching and Learning. WPI president Dennis Berkey noted that the gift was "from a family whose loyalty and generosity are woven into the fabric of the Institute's history."

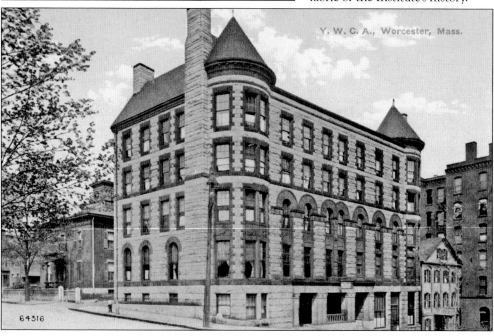

Y. W. C. A., Worcester, Mass.

64316

Born in Leicester, Massachusetts, in July 1830, Henry Clay Graton was one of the founders and the treasurer for the Graton & Knight Manufacturing Company. The company specialized in the manufacturing of belts and other leather goods. Their products were a success, leading to factories being opened outside of New England, and stores opened in Atlanta, Boston, Chicago, and several other cities in the eastern United States.

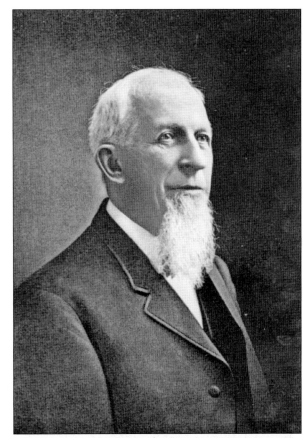

Henry Graton was married to Lucretia, who died in Worcester in 1910 at the age of 72. Their only child was a daughter, Millie Etta, who died in February 1871 at the age of four. Henry died in the city in March 1921, just five months shy of his 101st birthday. He was buried in the Graton family lot at Hope with his daughter, wife, and extended family.

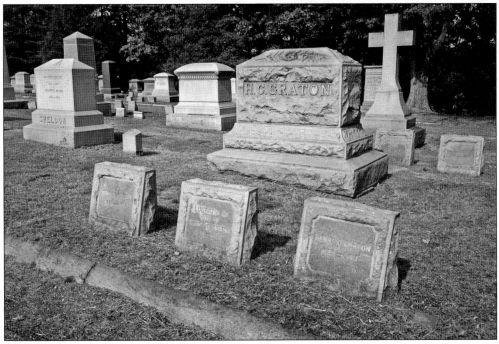

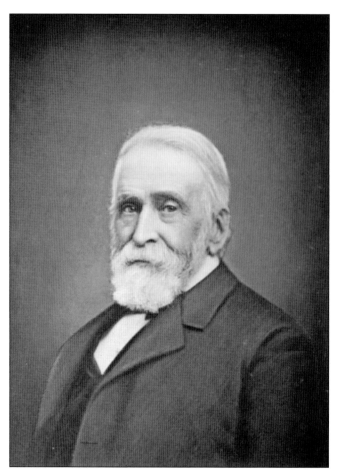

The Coes family had lived in America since long before the Revolutionary War. Loring Coes was born in 1812 and, according to all accounts, was still active and alert at the age of 94. Self-educated and self-made, Coes was not afraid of hard work. He and his brother bought Kimball & Fuller, woolen machinery makers, in 1836 but had to abandon their business when the Court Mills building burned in 1839.

Moving their business to Springfield, Massachusetts, the Coes brothers invented a new type of wrench that could be adjusted by the same hand holding it, leaving the other hand free. Loring returned to Worcester to patent the monkey wrench in 1841, becoming a wealthy and powerful resident of the city and serving on the city council for more than 30 years.

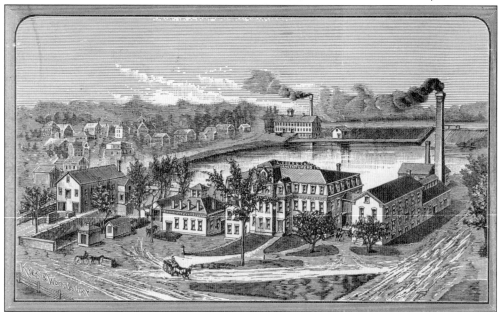

Loring Coes's son Frank Loring Russell Coes served in the Worcester City Guards and the 25th Massachusetts Infantry during the Civil War. Wounded, Frank returned to Worcester and married Persis J. Putnam in 1867. His son Frank Loring Coes attended the prestigious Worcester Academy and eventually worked in the family business. The fenced family lot in Hope Cemetery has several stones, some of which were designed by sculptor Andrew O'Connor Sr. (Courtesy of Tristan L. Hixon.)

Amos Bigelow came to Worcester in 1860 to work with his brother, builder George Converse Bigelow. The brothers built several churches in the city, including the Piedmont Congregational Church and St. John's Episcopal Church, along with a Baptist church and a Lutheran church. The brothers also constructed additions to the Taylor and Farely organ factory, shops for F.E. Reed, and residences on some of the smartest streets in town.

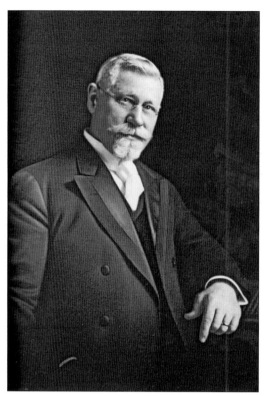

President of the Worcester Envelope Company, Ezra Waterhouse was a native of North Haven, Maine, where he was born in October 1856. He was educated in Rockland, Maine, public schools and went on to work in the Whitcomb Envelope Company in Worcester in 1875. In 1893, he began working as a mechanical engineer for the Worcester Envelope Company and was promoted to superintendent before being elected president of the company.

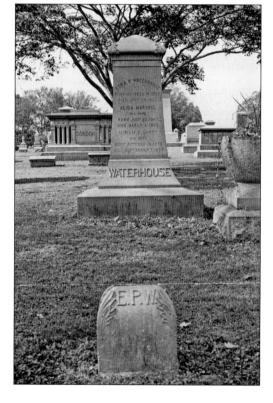

Ezra Waterhouse was married three times. His first marriage was in 1876 to Mary Revere, but it ended in divorce. He then married Mary Marshel, also known as Alida, in 1893. She died in 1903, and in 1904, Waterhouse married Miriam Sarty in Nova Scotia. Ezra died in Worcester in 1928, and Miriam died in 1935. Ezra and his second and third wives are buried in Hope in a large family plot.

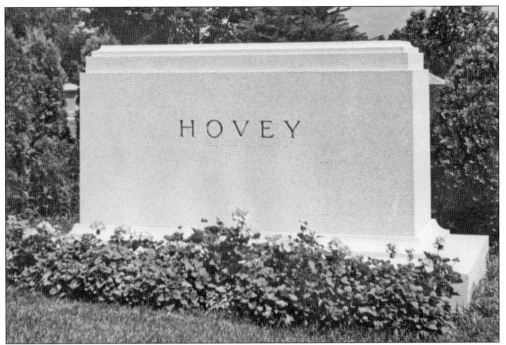

Henry Augustus Hovey was born and raised in Worcester and owned a café on Mechanic Street for over 30 years before his death in 1916. He came from a well-known family, and was a member of many clubs and organizations in and outside of Worcester, including the Knights of Pythias and the Order of Elks in Providence, Rhode Island. Hovey died in Worcester on December 22, 1916, and was buried in the family lot at Hope Cemetery. His wife, Ava (née Parsons), who died over 20 years later in 1938, along with their two sons Henry and George and their spouses, are also interred in the Hovey family lot. The above photograph shows the monument soon after it was erected, and the more modern view below shows the cemetery's changing landscape and additional monuments and markers. (Above, courtesy of the Rex Monument Company Inc.)

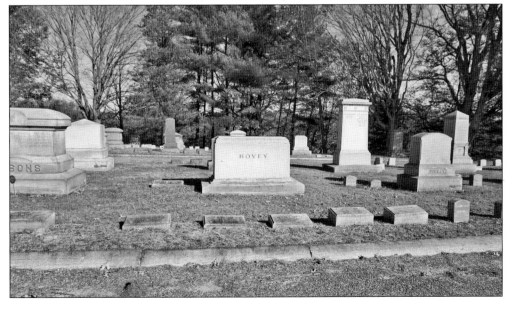

The Wesson brothers were born in the nearby town of Grafton. James Edwin Wesson worked in his family's shoe manufacturing business and was so excited by the new machinery used in the shoe-making process that he convinced his father to allow him to open his own small business in the family factory. He equipped his new business with the latest technology.

James Wesson and his younger brother, Walter Gale Wesson, later took over the family business and expanded. By the late 1880s, their company, J.E. & W.G. Wesson, was growing so rapidly, new premises had to be found for the more than 200 employees. Their shoe-making capacity was estimated at 1,500 pairs a day.

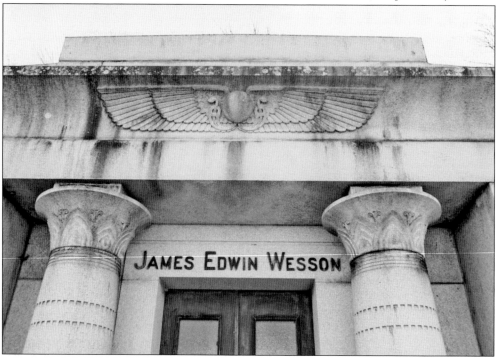

Worcester, Mass., Polytechnic Institute, Boynton Hall.

James Wesson married Anna Endora Stoneberger in 1865, but Walter Wesson never married. Walter, who had graduated from Worcester Polytechnic Institute in 1886, retired from the shoe business and died in 1939 at the age of 74 "after being stricken with a heart attack in his room at the Worcester Club." James died in 1926 at the age of 84. They are both buried in Hope Cemetery.

Born in Dundee, Scotland, William Alexander Denholm was the youngest of eight children. After his father died, Denholm went to work in a dry goods business at only 13 years old; he later went to London, traveling to New York City to manage part of the British business that employed him. Denholm moved to Worcester and purchased a dry goods business, Finley, Lawson & Kennedy, on Main and Mechanic Streets.

William Denholm later partnered with William McKay, and the store Denholm and McKay was born. The business was quite successful, moving to Jonas G. Clark's new block on Main Street, where it became the largest store of its kind in New England outside Boston and Providence. (Courtesy of the American Antiquarian Society.)

William Denholm was an important man in his adopted city, serving as director of the First National Bank and the Worcester Electric Light Company. He was also a member of the Old South Church, the oldest church organization in the city. Old South Church merged several times with other congregations and is now the First Congregational Church in the Tatnuck Square section of Worcester.

English-born Matthew J. Whittall immigrated to Worcester and worked as the superintendent of the Crompton Carpet Mill in the 1870s. He later left Crompton and began his own factory in 1874. Crompton Carpet Mills, originally owned by George Crompton and Horace Wyman, went out of business in 1879, and its successor, the Worcester Carpet Company, was eventually acquired by Whittall and was in operation until 1950.

Whittall Mills was one of the largest employers in the city of Worcester during the first half of the 20th century. The carpets produced in the mills were selected by Pres. William McKinley to be used in the White House. The mill building still stands and is listed in the National Register of Historic Places. Today, it houses Rotman's Furniture Company.

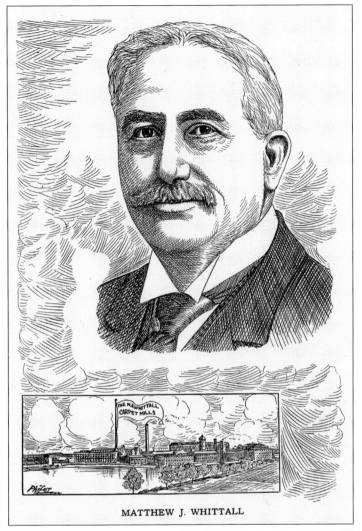

MATTHEW J. WHITTALL

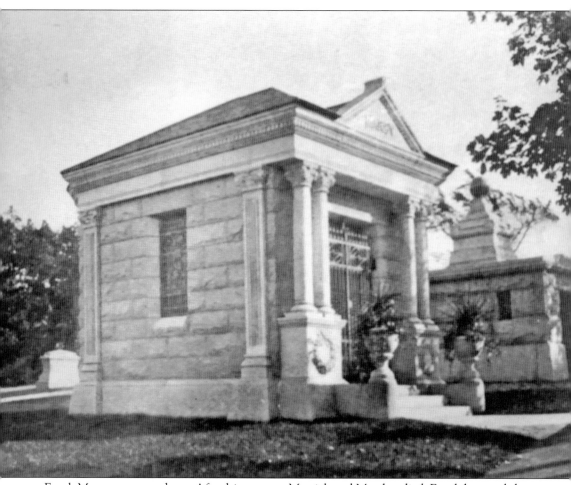

Frank Marcy was a good son. After his parents, Merrick and Martha, died, Frank honored them by erecting a beautiful mausoleum in Hope Cemetery. "The design of the building is classic Greek, simple and dignified, without any pretensions to ornate ornamentation, yet is tasteful and pleasing in appearance," *Worcester Magazine* noted in 1903. The building was large, at 14 by 24 feet, and made of granite quarried in Concord, New Hampshire. Two Italian marble doors, each weighing 600 pounds, grace the front, guarded by solid brass ornamental gates. The inside is tile, with white tile along the walls and a domed ceiling with mosaic tile "of rich, artistic designs in quiet colors," according to *Worcester Magazine*. The mausoleum even had stained-glass windows. Merrick Marcy was descended from an old New England family, with a Revolutionary War soldier in his family tree. He spent his boyhood on a Connecticut farm before coming to Worcester and learning the machinist's trade.

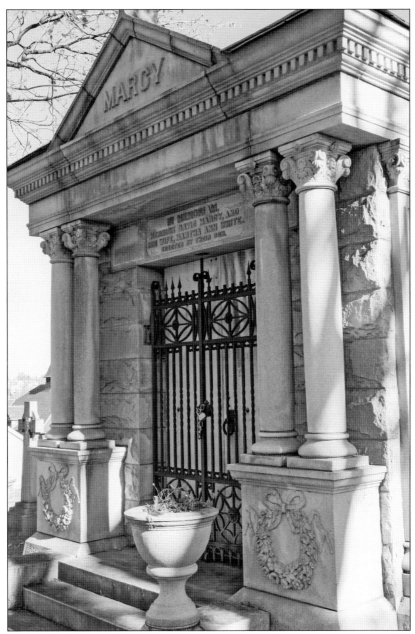

Merrick Marcy became a partner in the second firm in the country to manufacture machine-made screws, and began patenting his own innovations, including sheet metal spinning rings, in the United States and England. According to *Worcester Magazine*, Merrick was "a man of modest, retiring disposition, and honest and upright in all his dealings." He married Martha Ann White, a descendent of Perregrine White, who arrived with the Pilgrims at Plymouth in 1620. Her father commanded a privateering vessel during the War of 1812. Like his father, Frank was an inventor. He filed for several patents, including one for a "spinning-ring" in 1901 and one for "Hose or Tubing," which was filed in 1903 with George Otis Draper of the Draper Corporation in Hopedale, Massachusetts, being an "assignor of one-half" of the patent. Frank Marcy was married to Carrie Amelia Phetteplace. Frank died in 1914, and Carrie lived another 14 years.

Born in Alton, New Hampshire, in 1830, Andrew Hill Hammond is best known in the city as the founder of the Hammond Reed Company. He came to Worcester in 1851 and found employment in the malleable iron works industry and later in a foundry. Music was Hammond's passion, and in 1868, he built his first organ reed factory on May Street, which quickly became the largest organ reed factory in the world.

Andrew Hammond married Rhoda Barber in 1860, and the couple had six children, including Eleanor, who graduated from Oxford University and Chicago University, and Mabel, a graduate of Radcliffe College. Rhoda died in Worcester in May 1891 at the age of 50, and Andrew passed in March 1906 at the age of 75. Andrew, Rhoda, and Eleanor are buried in Hope in a corner lot with ornately carved headstones.

Emma Frances Dearborn was headed toward a professional life before she married. A Worcester native, after graduation from Worcester High School in 1878, she studied vocal music under Madame Louisa Cappiani, considered a grand opera singer, who had performed at the Metropolitan Opera House in New York City. (From the collection of Worcester Historical Museum.)

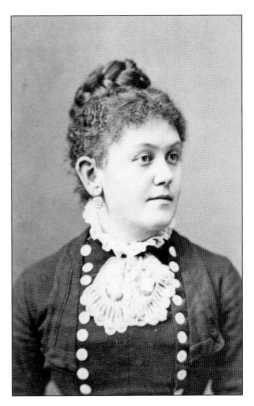

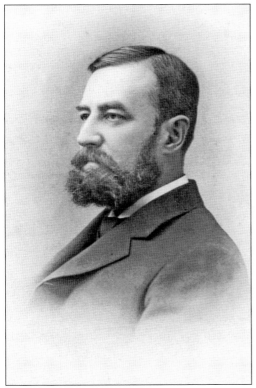

When Emma Dearborn married Henry Francis Harris in 1883, thoughts of a career took a back seat so she could concentrate on the couple's two daughters. But she put her musical talents to work. She was director of the Universalist church choir and gave frequent concerts. She was considered a lady of culture and an accomplished musician at the time.

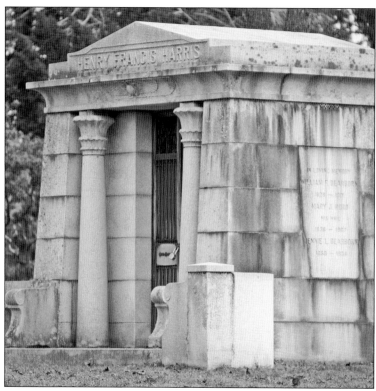

Emma Dearborn's husband, Henry Harris, was born in West Boylston, Massachusetts, and graduated from Boston University Law School. Harris practiced law in Worcester starting in 1874. After the death of his father, Charles, he was elected treasurer of the West Boylston Manufacturing Company and later served as a director of the L.M. Harris & Company Manufacturing Company. (Courtesy of Tristan L. Hixon.)

Henry Harris was a busy attorney in town, representing local banks and trust companies, but also a busy man—he was a trustee of Worcester City Hospital, the Massachusetts Homeopathic Hospital, Worcester Academy, and Worcester's Home for Aged Women, which has a section in Hope Cemetery. He was an active member of the Worcester Art Museum and served as chairman of the board of First Universalist Church in the city.

After Henry Harris died in 1915, Emma gave their home on Lincoln Street to the working women of Worcester in his memory. The home became known as the Harris Memorial Club House, eventually morphing into the Worcester Girls Club, a place to give low-income girls an advantage with educational and social opportunities. (Courtesy of Girls Inc.)

Emma Harris was greatly involved, wanting to give girls from low-income families a leg up in the city. The home is now gone, but the "club" remains in the Vernon Hill section of the city. Known today as Girls Inc., Emma Harris gave a gift to Worcester girls that has lasted over a century. (Courtesy of the American Antiquarian Society.)

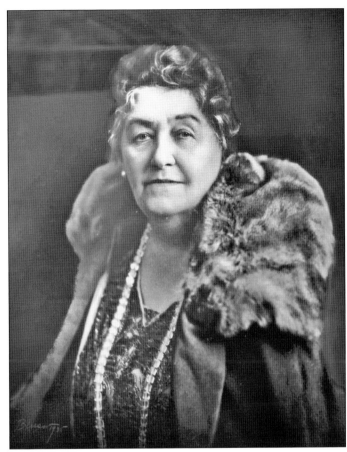

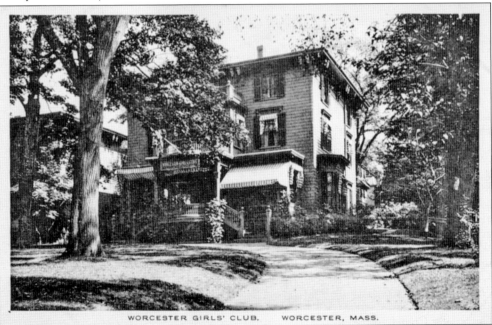

WORCESTER GIRLS' CLUB. WORCESTER, MASS.

Born in Scotland, Samuel Mawhinney came to Massachusetts in 1848, and moved to Worcester during the Civil War. His business was making shoe lasts, wooden molds on which shoes were constructed. He was so successful he erected a factory on Church Street. Mawhinney served a term on the Worcester City Council, and although he moved his business to Brockton to be closer to the shoe industry, he is buried in Hope Cemetery.

Robert Golbert was born in Boston in 1837 and lived there until his father died when he was 12. He briefly moved to Hanson, Massachusetts, but returned to Boston five years later when he began working for a manufacturing company. He came to Worcester in 1856 and began working in the factory of Samuel Mawhinney, eventually becoming a partner in the firm.

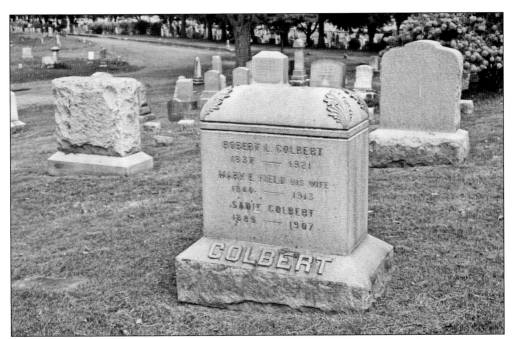

Robert Golbert married Mary Field, a native of Nantucket, Massachusetts, in 1865, and together they had a daughter, Sadie, born in 1885. Sadie died in 1907 at the age of 22 after contracting tuberculosis, and is buried in Hope. Mary died six years later in 1913, at the age of 73. Robert died in 1921 at the age of 84, and is buried in Hope with his wife and daughter.

A number of important buildings in Worcester were built by George Converse Bigelow. Born in 1828, Bigelow came to the city and formed a carpentry and building company in 1860. The firm, G.C. and A.E. Bigelow, built several churches, including Piedmont Congregational Church at the corner of Piedmont and Main Streets, St. John's Episcopal Church on Lincoln Street, and the Armenian Church on Laurel Street. He died in April 1892.

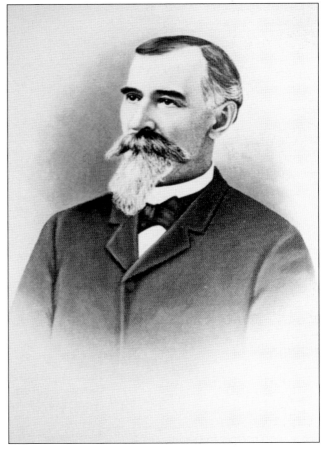

George Bigelow's wife, Eleanor J. Doane, was an important woman in her own right. Educated at Wesleyan Academy in Wilbraham, Massachusetts, and Oread Collegiate Institute in Worcester, she was active in the Piedmont Church. Their daughter Alice was also educated at Oread and married Frank P. Knowles of Crompton and Knowles Loom Works in 1879.

Eleanor Bigelow was interested in charitable and educational work, and was known to be liberal and fair, with a cheerful and energetic nature. She and her husband are buried in Hope Cemetery.

Three

A City of Diversity
In Life and in Death

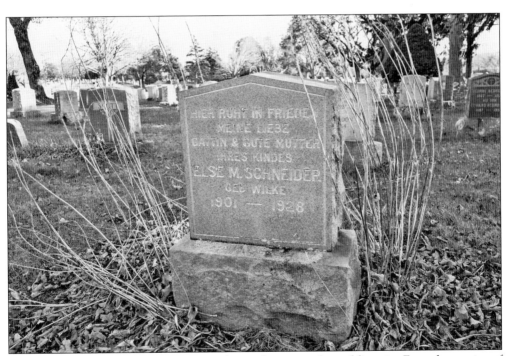

As different industries grew in Worcester, the city became a place of diversity. From the coming of Irish immigrants to build a section of the Blackstone Canal, to the arrival of Swedes, Armenians, Russians, and even Chinese, Worcester grew ever more diverse. This stone, engraved in German, speaks to the melting pot. It translates as, "Here rests in peace / my love / wife & good mother / your child / Else M. Schnieder."

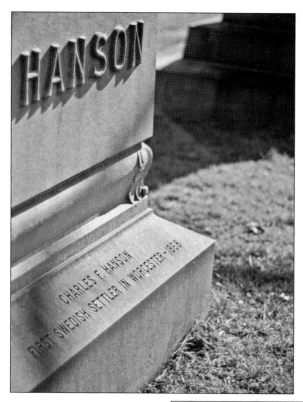

Charles Hanson has the distinction of being the first Swedish person to settle in Worcester. He came to America in 1865 and lived in Boston, where he worked in a piano factory. In September 1868, Hanson moved to Worcester and within a year and a half opened his own business dealing with musical instruments. He died in 1921 and is buried with his wife, Eliza, and children in Hope. (Courtesy of Tristan L. Hixon.)

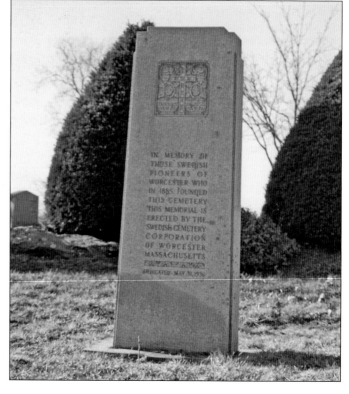

Charles Hanson was just the first of many people of Swedish heritage to settle in Worcester. A large wave of Swedish immigration occurred in the latter decades of the 1800s, quickly making Worcester a hub of Swedish activity. Many churches were established, along with countless businesses and two Swedish cemeteries. This monument stands at the entrance to Old Swedish Cemetery across the street from Hope.

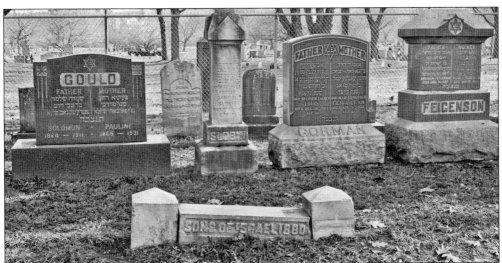

Several sections along the eastern border of Hope Cemetery are the final resting place of many of Worcester's Jewish residents. The Jewish community of Worcester purchased several lots, beginning in 1881 with the Sons of Israel lot. The Jewish community later established its own cemeteries, including Worcester Hebrew, Sons of Jacob, and Chevra Kadisha cemeteries off Stafford Street and B'nai Brith Lodge Cemetery on St. John's Road.

This stone found in one of the Jewish sections is unique in that it looks like it is inside of a temple. It belongs to Betsey Machinist, who was born in Russia and came to the United States in the mid-1880s. She died in Worcester in May 1907 at the age of 59, and is buried in Hope, where her stone catches the eye of whoever passes by.

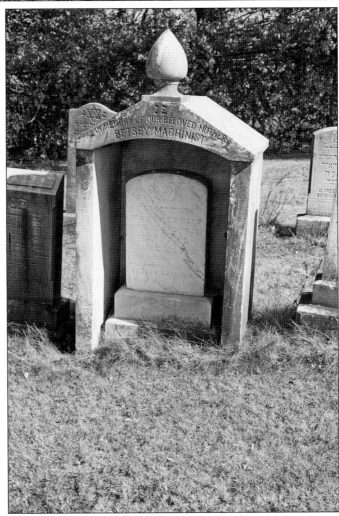

Born in Worcester in 1881 to Norwegian parents Olaus and Emile, Henry L. Hanson spent his early life in the city, attending local public schools before his family relocated to Ohio. The family returned to Worcester in 1896, at which time Henry began working for the Sears Bicycle Manufacturing Company. He left that company to work for the Prentice Brothers machine shop and later was employed by the McCloud, Crane & Minter Company.

Henry Hanson married Thekla Larsen in Worcester in 1903, and they had three children: Clifford, Henry, and Charlotte. Henry died in 1939, and Thekla died 20 years later in 1959. Both are buried in Hope Cemetery along with their children under a pair of trees. Their gravestone features an engraving of a calla lily, frequently related to death.

John Rankin was an Irish immigrant. He arrived on American soil at the age of eight from County Antrim and soon learned the carpenter's trade. In 1888, Rankin went into partnership with Samuel Woodside, and their building and contracting company built a number of city buildings including the Adams Square fire station, the Bloomingdale schoolhouse, and the Stephen Salisbury home on Institute Road.

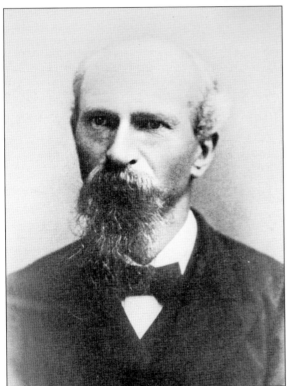

Carl C. T. Thomas lived the American rags-to-riches story. Born in Prussia, his mother died when he was just a child. His father remarried, bringing his new wife and three children to the United States. But his father died on the voyage, and his stepmother disappeared when the ship landed at Ellis Island. Carl and his young siblings, John and Mary, were abandoned. But he took care of them.

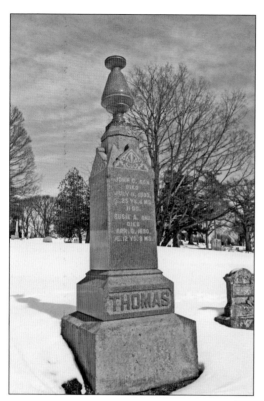

They came to Massachusetts, and Carl Thomas served in the Civil War and was wounded. His brother John also fought. Carl came to Worcester, working as a cabinetmaker and starting Thomas & Company with Elisha Witherell. The firm specialized in interior woodwork, including altars and pews in churches all over Worcester and New England. Carl was a member of the George H. Ward Post of the Grand Army of the Republic.

Carl Thomas married Louise D. Allen in 1865. He was reportedly a kind man who made many friends. But several of their children died young, including two-year-old Talbot and twelve-year-old Susie. Son John died at 25. Daughter Bertha Allen Thomas was born in Worcester and was active in the Old South Church. She died in Pine Bluff, North Carolina, at 33, and is buried in Hope Cemetery.

Not all immigrants came from Europe. Henry I. Shue Chin and his wife, Ung Shee Chin, were one of the first native Chinese families to call Worcester home. Two of their children were the first children of Chinese descent born in Worcester. Henry owned and operated a Chinese market on Mechanic Street, which had once been considered a small Chinatown. The business survived until urban development forced its closure. (Courtesy of Tristan L. Hixon)

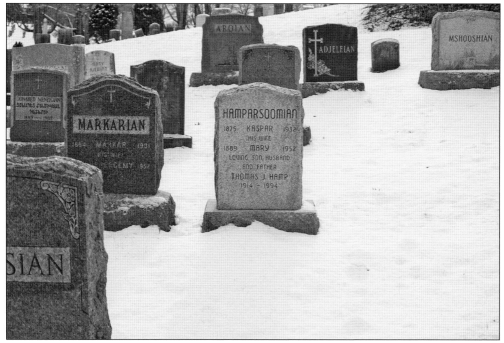

There are several sections throughout the cemetery where there are numerous Armenian burials, with one of the oldest on a hill near the northeast side of the cemetery near the Jewish Section. The grave of Kaspar Hamparsoomian, his wife, Mary Mouradian, and their son Thomas sits in the center of this section of smaller upright stones.

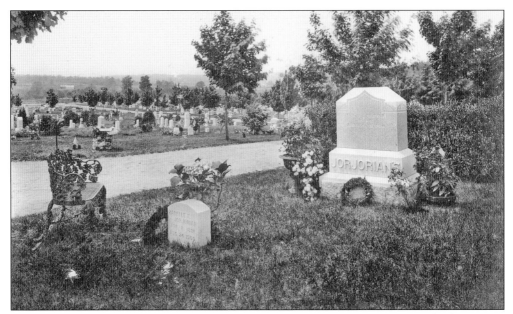

Zabelle Jorjorian was a native of Turkey who immigrated to the United States in the late 1880s. She was working for a family in the nearby town of Auburn when tragedy struck. She was burned when her clothing caught on fire while she was working at a stove. Her death certificate shows she was brought to Worcester City Hospital on August 23, 1905, suffering from second- and third-degree burns and surviving for 18 hours before succumbing to her injuries the next day. (From the collection of Worcester Historical Museum.)

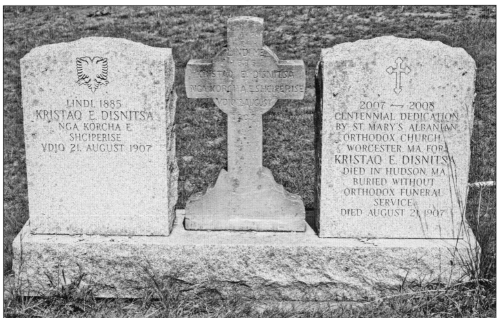

The stone for Kristaq Disnitsa is unique and important. He was an immigrant from Albania and died in Hudson, Massachusetts, in 1907, without an Orthodox funeral. His death was a catalyst for the founding of the Albanian Orthodox Archdiocese in America a year later. His stone was expanded by St. Mary's Albanian Orthodox Church in 2008 for its centennial dedication.

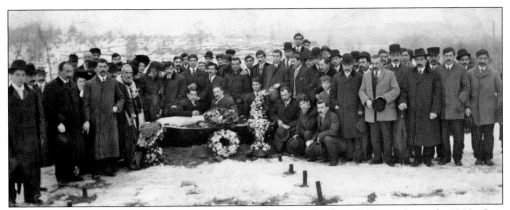

This photograph shows a committal service in Hope from the late 1800s or the early 1900s. It is believed to be an Orthodox funeral judging by the clothing worn by the priest, and possibly took place in early winter, as there is snow on the ground but the ground is not frozen solid. Note the few women on the left. (From the collection of Worcester Historical Museum.)

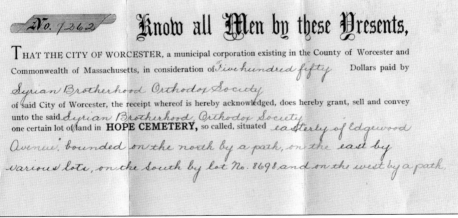

The Syrian Brotherhood Orthodox Society purchased a lot in Hope Cemetery along the southeast border for a sum of $550 in the early 1900s. In 1917, there were 22 interments in this lot, including several infants. Most were members of St. George's Orthodox Church on Wall Street, with a couple of burials for Syrians living outside of the city. (Courtesy of the Archives of St. George Orthodox Cathedral.)

HOPE CEMETERY - WORCESTER. MASS.			Opening S_W	14 00
INTERMENT ORDER NO.		X	Bearers and Cov.	
Date *Tuesday Jan 24 1933* 3 P.M.			Low. Dev.	
Lot-S. G. *10203* Sec. *12* Grave *185*			Trim	
Owner			Chapel (Heated)	
Box *No* Size *6*			Overtime	
Remarks			Extra Deep	
			Lower Body	
Name *Mary Streeter*			Sunday or Holiday	
Address				
Date of Death Age				
Undertaker				
Ordered by				
Address			Total	

Above is the interment order from Hope Cemetery for Mary Streeter from January 1933. It shows the lot, section, and grave number in the Syrian Brotherhood Orthodox Section. The certificate below is from the society, showing that the lot was paid for by Mary's husband, George Streeter, and is embossed with the seal of the society. As the society was the sole owner of the Syrian section, it was able to sell graves, with the family of the deceased only paying the cemetery for the costs associated with burial, including the opening of the grave, and the use of the chapel if needed. (Both, courtesy of the Archives of St. George Orthodox Cathedral.)

Syrian Brotherhood Orthodox Society
Worcester, Massachusetts
Founded 1905

𝔗𝔥𝔦𝔰 𝔦𝔰 𝔱𝔬 𝔠𝔢𝔯𝔱𝔦𝔣𝔶 that the grave Number *185* in the Syrian Brother-hood Orthodox Society lot in Hope Cemetery is the property of Mr. *George Streeter* the price of which was paid in full to the treasurer of the Society. Therefore the society has issued this certificate on *13th February 1933*.

SYRIAN BROTHERHOOD ORTHODOX SOCIETY

NOTE: This certificate is not official if the original seal of the Society is not affixed thereto.

Name *Mary Streeter*
Date of Death *January 25 - 1933*

Shokri K. Suydawe
B. K. Forzley
Frida K. Forzley Sec'ty

Nº 185

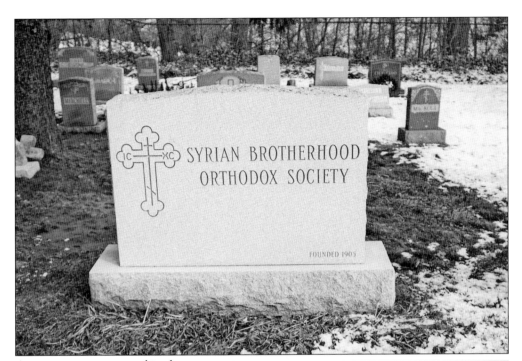

A monument was erected in the Syrian Brotherhood Orthodox Society lot in honor of the society. Carved on the front of the stone is an Orthodox cross and the date of the founding of the organization. The reverse side features the names of the 14 charter members at the founding of the society in 1905. Also listed on the back are 12 corporate members of the society.

Archbishop Victor Aboassaly, also spelled Abo-Assaly, was the head of the Syrian Orthodox Antiochian Church in North America in the mid-1920s to the mid-1930s. He was born in Damascus, Syria, and came to America in 1922; two years later, he was elected bishop of the church. He served in that capacity until his death in 1934 in New York. (Courtesy of the Archives of St. George Orthodox Cathedral.)

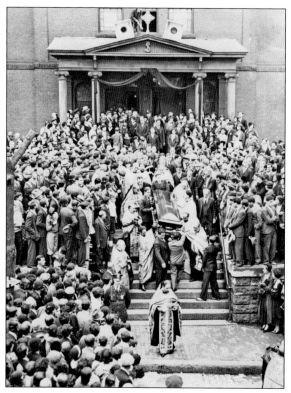

With a special permit from the city, Archbishop Aboassaly was buried in the courtyard of St. George's Church on Wall Street. When St. George's Orthodox Cathedral was built on Anna Street in the 1960s, the archbishop was removed from the courtyard and buried in Hope Cemetery in January 1970. The large Byzantine-style dome and cross was built above a statue of Aboassaly and was moved to Hope with the archbishop. He was interred in Hope until 1996, when the Syrian Church and an heir to Archbishop Aboassaly requested his removal so he could be interred in Holy Resurrection Cemetery at the Antiochian Village in Pennsylvania. In September that year, his body and monument were removed from Hope. (Below, courtesy of the Archives of St. George Orthodox Cathedral.)

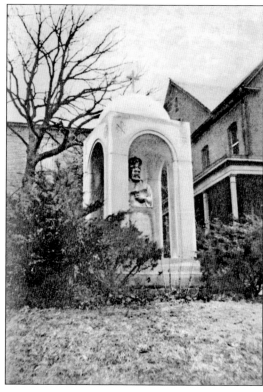

In 1983, the Council of Eastern Orthodox Churches of Central Massachusetts decided that the Orthodox community should have a common burial ground. Delegates met with City of Worcester officials, and a section of Hope was selected to be the Orthodox Section. A granite altar table was erected on the lot where several Orthodox churches in the city held Memorial Day services. The altar, designed by Timothy Rucho of Worcester, reflects the ornateness and symbolism of the Orthodox churches and is inscribed with the phrases, "Jesus Christ Conquers," and "Jesus Christ Is Victorious." The large gold painted wrought iron cross directly behind the altar was originally atop St. George's Orthodox Cathedral on Wall Street, which was previously St. Joseph's Catholic Church. It was placed in the cemetery after the church moved to its current location on Anna Street. (Below, courtesy of the Archives of St. George Orthodox Cathedral.)

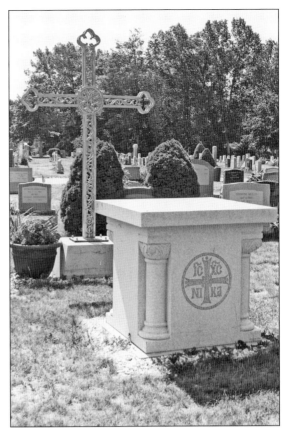

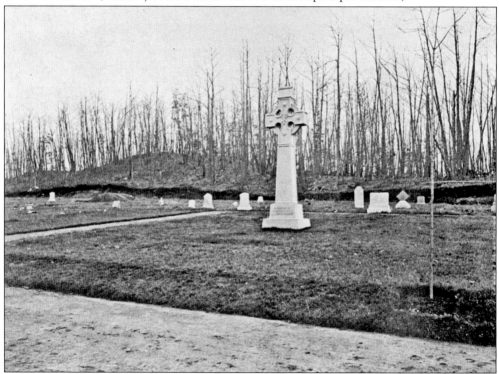

All Saints Episcopal Church in Worcester also owns a lot within Hope Cemetery. Purchased in 1886 by Edward and Mary Davis, a small section of Hope was given to the church for the burial of communicants dying dependent on the charity of the church. This lot was only able to accommodate 22 burials, so in 1896, All Saints exchanged the plot for a larger one large enough for 72 interments. (Courtesy of the Archives of All Saints Episcopal Church.)

This lot is marked by a large Celtic cross made from pink Milford granite, which was consecrated in July 1897. The lot is occupied by a variety of people, from young infants to elderly parishioners who could not afford to be buried elsewhere. Perishing in a house fire, brothers George and Walter Henze were only 10 and 12 years old when they were interred in this lot. (Courtesy of the Archives of All Saints Episcopal Church.)

Amos Webber was a free man of color in a dangerous time. Born in 1826, he moved to Worcester from Philadelphia to work in the Washburn and Moen Wire Company. A member of the 5th Massachusetts Cavalry during the Civil War, one of only four "colored" regiments from the state, Webber rose in rank to become a quartermaster sergeant.

After the war, Amos Webber joined the Grand Army of the Republic in Worcester, forcing the George H. Ward Post 10 to integrate and allow soldiers of color to join the white veteran members. Amos and his wife, Lizzie, died separately in the same year, 1904, and are buried near their son Harry. Harry's body had been removed from Philadelphia to Hope Cemetery before his parents died.

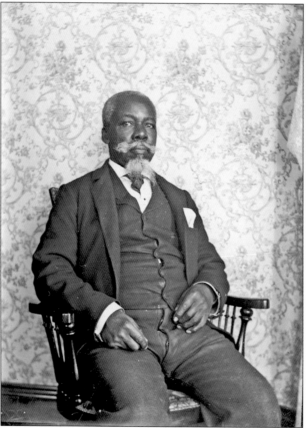

Amos Webber kept a daily diary for most of his life. Its discovery has given historians a rare insight into the life of an African American man before, during, and after the Civil War. The family is buried on the edge of a hill within yards of the fenced lot of Worcester industrialist Loring Coes, showing the integration of Hope Cemetery.

David T. Oswell was not an ordinary man. He lived on Dewey Street in Worcester, near the intersection of Chandler Street and Park Avenue. When he died of Bright's disease in 1902, three clergymen conducted the service: Reverend Pearson of Bethel AME Church, Reverend Lee of Belmont Street AME Zion Church, and Reverend Conway of John Street Baptist Church. A mixed quartet sang, and his home was filled with flowers. (Courtesy of Frank Morrill.)

Born in Boston around 1837, David T. Oswell was married to Adeline, and they had five children. He was a black man living in the mostly white north, and he escaped to Canada in the 1850s to avoid the Fugitive Slave Act; however, he came back to the United States after the Civil War and settled in Worcester. (Courtesy of Frank Morrill.)

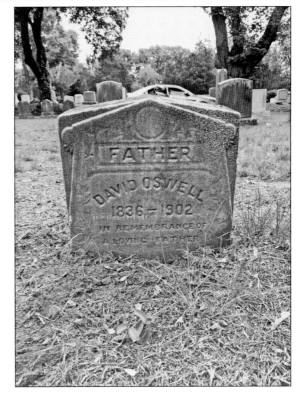

David T. Oswell worked as a barber, but that was only part of the story. Known around the city as "Professor Oswell," he taught generations of residents, including prominent white patrons, how to play the violin and guitar. Oswell led his own orchestra and wrote several operettas. His daughters were also musical, performing with their father throughout New England. Oswell was revered in Worcester and is buried in Hope Cemetery. (Courtesy of Frank Morrill.)

Bethany Veney lived the life of a slave. Born in Virginia in 1812, she was of African and Blackfoot Indian ancestry, and lived for 40 years enslaved before being bought and freed by a Providence, Rhode Island, couple. She settled in Worcester, working as a cook and saving her money. She eventually returned to the South to free many of her relatives. Veney eventually bought 16 plots in Hope Cemetery, and although many of the lots have been filled, no monuments to the family currently exist. But Veney is not the only former slave in Hope. Escaped slave Allen Parker left his bondage during the Civil War. He fled his North Carolina master with two others, paddling in a canoe to a Union patrol boat to become contraband of war. There were several contraband camps in that state, including at New Berne, Hatteras, and Roanoke Island. Parker eventually settled in Worcester after working as a ship steward and in the timber industry in Maine. He published a book of his life story before he died in 1906.

Four

FOR THOSE WHO SERVED

HEROES FROM ALL WALKS OF LIFE

Hope Cemetery is filled with heroes. There are at least 1,400 veterans of the American Civil War buried here, along with service members from the Revolutionary War right through today. But heroes serve our country in many ways. Firefighters from the city are memorialized in the Worcester Fire Department lot and the towering Coombs monument—and heroes are not just men. (Courtesy of Tristan L. Hixon.)

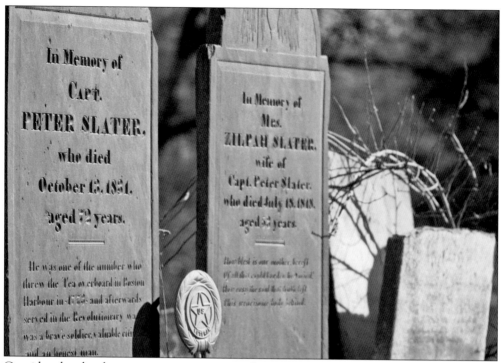

Considered to be the youngest participant in the Boston Tea Party, Peter Slater was born in England and was only a boy of 13 when he helped throw British tea overboard on December 16, 1773. At the age of 16, he joined the Continental Army and fought with Gen. George Washington at Valley Forge in 1777. Slater was taken prisoner by the British in 1779 and held for five months in New York City before being released to fight again. After independence, he returned to Worcester, serving in the Worcester Artillery Militia Company and on the board of selectmen. It is said he was never sick in his life until just before his death. He is buried in Hope Cemetery, where a separate monument was erected on July 4, 1870, recording the names of 63 Tea Party participants. (Below, courtesy of Tristan L. Hixon.)

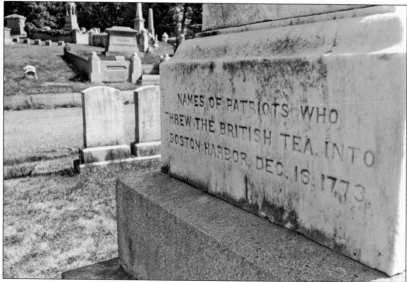

Jeffrey Hemenway was a free black man who fought for his country. He was a veteran of the French and Indian War fighting for the British, but also fought in the Revolutionary War at the Battle of Bunker Hill. Hemenway was of African and American Indian ancestry. He lived in this house in Framingham but settled in Worcester, marrying Hepsibeth Crosman, a woman of the Nipmuc Indian tribe. The couple owned a farm in the area of May Street, now a busy urban section of Worcester. Jeffrey was 27 years older than Hepsibeth, and when he died in 1819, she needed to care for herself. She did laundry and made wedding cakes, becoming famous for her baking. Her services were always in demand. (Above, courtesy of the American Antiquarian Society.)

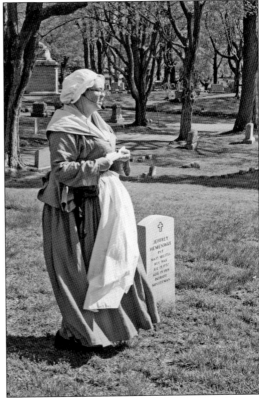

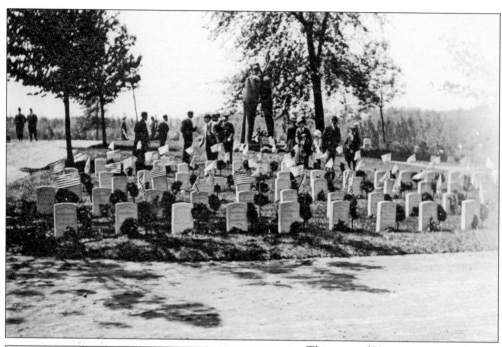

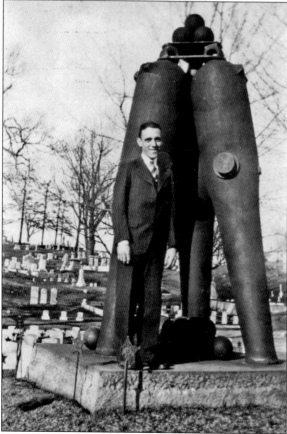

This area of Hope was reserved for Civil War veterans who were members of the Grand Army of the Republic Post 10, named after Gen. George H. Ward, who was killed at the Battle of Gettysburg. George had been injured earlier in the Civil War and had his leg amputated, but he went back to battle with his men and died on July 3, 1863. (From the collection of Worcester Historical Museum.)

Dedicated on Memorial Day 1892, the lot has two sections. This section has a tripod of cannons and cannon balls that came from the Charlestown Navy Yard to stand as symbols of the horrors of war. The Worcester GAR post and lot in Hope was integrated; African American soldiers are buried there, and two who perished during the conflict are listed on the Worcester Soldiers' Monument on the city's common. (From the collection of Worcester Historical Museum.)

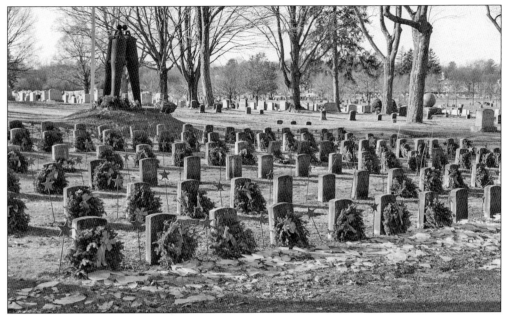

Grandson of patriot Jeffrey Hemenway, Alexander Freeman Hemenway was born in Worcester. Like his grandfather, he served his country, this time in the famed 54th Massachusetts Infantry Regiment during the Civil War. After the war, he was a member of the integrated Worcester GAR post, and worked as a barber in the city. After he died in 1896, he was buried in the GAR lot in Hope Cemetery.

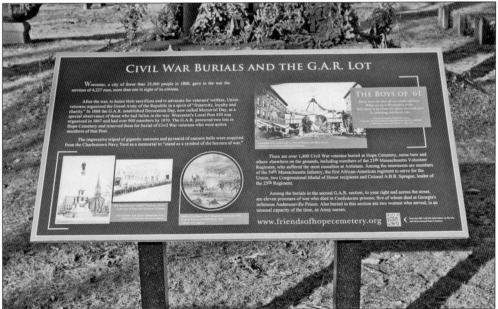

Alexander Hemenway was not the only African American Civil War veteran to be buried in the GAR lot in Hope. George L. Bundy also served for the 54th Massachusetts and was wounded at the Second Battle of Fort Wagner—the battle where Col. Robert Gould Shaw was killed and where the 54th earned its fame. George Rome and Henry Toney served in yet another Massachusetts "colored" regiment, the 55th.

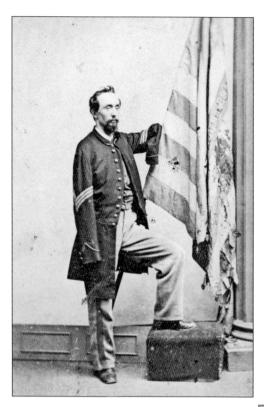

Irish immigrant Thomas Plunkett served as a corporal during the Civil War. He was wounded at the Battle of Fredericksburg, Virginia, in December 1862, and is a hero of that battle; he carried the regiment's colors in the face of the enemy and had both arms shot off in the process. Plunkett received the Medal of Honor for his bravery and joined the Grand Army of the Republic. (Courtesy of the Library of Congress.)

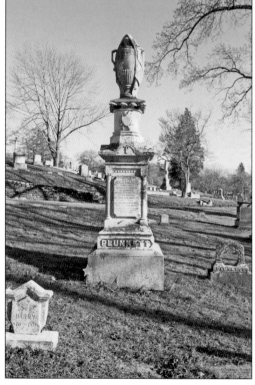

Col. William Clark noted that Thomas Plunkett "seized the colors and carried them proudly forward to the farthest point reached by our troops during the battle. When the regiment had commenced the delivery of its fire . . . a shell was thrown with fatal accuracy at the flag. Both arms of the brave Plunkett were shot off and literally carried away, and once more the colors, wet with the bearer's blood, were brought to the ground."

Warren A. Alger came to Worcester with his mother, Susan, in the early 1850s. His father died when he was only nine, and his older brother died a year later. During the Civil War, he was captured by Confederate forces during the Battle of Ball's Bluff. Although uninjured, a bullet did travel through his shoe between his stocking and the hollow of his foot. He was released after four months. (Courtesy of Archives-Museum Branch, the Adjutant General's Office.)

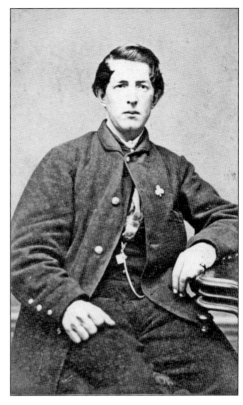

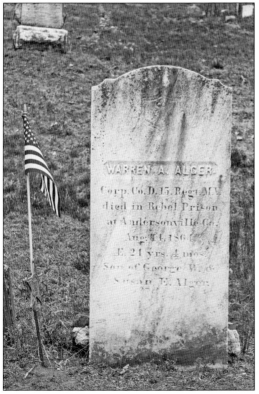

Warren Alger returned to war and was captured again during the Battle of Gettysburg. After his release, he was again captured and sent to the Confederate prison camp at Andersonville, Georgia. It was there, in horrid conditions, that Warren died on August 14, 1864. After the war, his body was returned to Worcester where a funeral took place at the Central Church Chapel, with burial following in Hope.

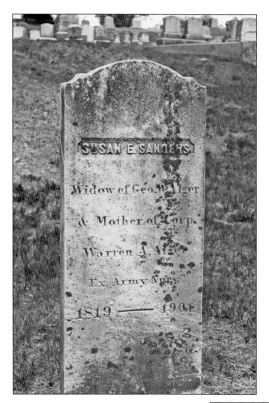

While her son was serving in the Army, Susan Alger was also serving her country. She volunteered as an Army nurse and was serving at McDougall General Hospital in Fort Schuyler, New York. She returned to Worcester and died at the age of 81, and while her late husband was buried in Winchendon, she was buried in Hope, next to her son Warren.

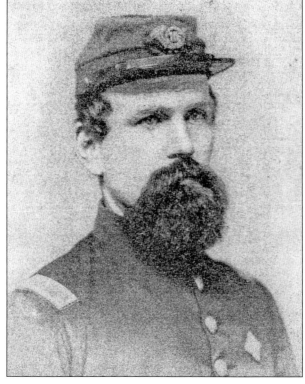

Joel H. Prouty enlisted in the Union Army in April 1861. When the men of the 6th Massachusetts traveled from Worcester to Baltimore, they were attacked by a mob, and all their possessions were stolen. The men were received by Pres. Abraham Lincoln in Washington, sleeping under the rotunda of the Capitol, which was still under construction. (Courtesy of the Auburn Historical Museum.)

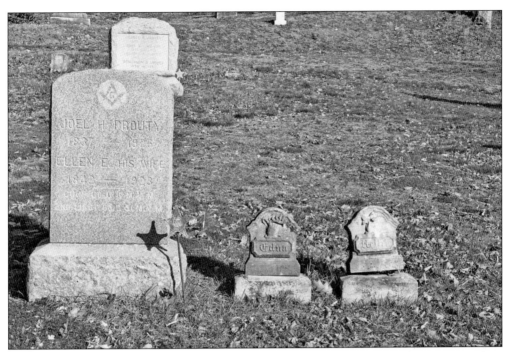

In 1864, Joel Prouty left the military and settled in Auburn, where he and his wife, Ellen Patch, raised eight children. He was an active member of the Masons in Worcester, and after his death, the Joel H. Prouty Lodge was chartered in his honor in Auburn. Prouty's great-grandson donated his Civil War uniform jacket and revolver to the Auburn Historical Museum, where it can be viewed today.

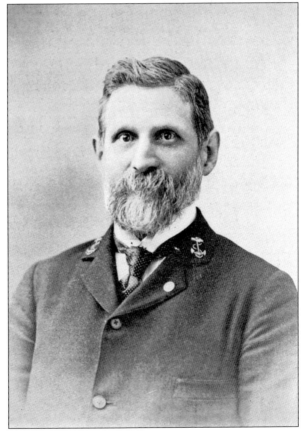

Educated at Harvard University, Dr. Benjamin Franklin Clough was born in Kennebunkport, Maine, in 1838. During the Civil War, he joined the US Navy, serving as a surgeon's steward aboard the USS *Black Hawk* and USS *Red Rover*. Clough went back to school after his discharge, attending Harvard Medical School, and moved to Worcester to practice medicine on Myrtle Street. He was an active GAR member.

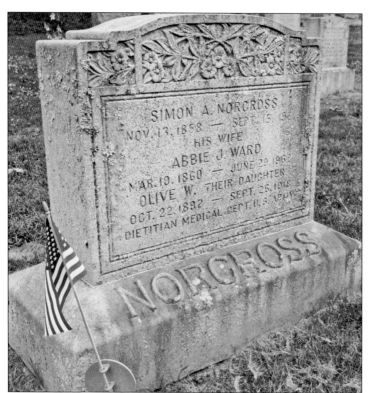

Adopted into the Norcross family, Olive Norcross was the niece of Simon and Abbie Norcross, and excelled at school, studying science and household arts at Framingham Normal School. She became a dietitian and worked at several local hospitals. When World War I started, she signed on, working as chief dietitian at Camp Dix in New Jersey. She died during the Spanish flu pandemic in September 1918. She was 25 years old.

A native of Lawrence, Massachusetts, Charles Robert Seed was living in Worcester when he joined the Naval Reserve Force in March 1917. During his service, he served on board the USS *Wakiva* for which he was awarded a letter of commendation for "meritorious service rendered" during an engagement with an enemy submarine. Lieutenant Seed died on October 8, 1918, at Hahnemann Hospital in Worcester due to pneumonia.

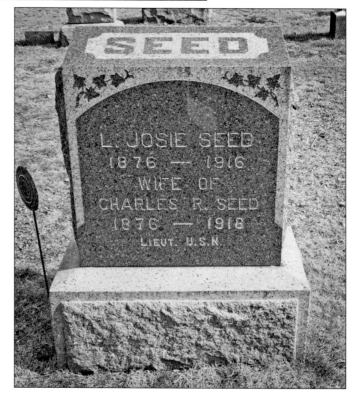

Henry Rockwood Knight served during World War I, although his service was not required since he was above the draft age and had dependents. Eager to go to the front, he urged his comrades to accompany him. In April 1918, during the Battle of Apremont Woods, Knight became the first commissioned officer from Worcester to be killed in battle. He was awarded the French Croix de Guerre for his gallantry in action. After the war, his body was moved to Hope Cemetery. His grave honors his military service, reading, "He was what we soldiers call a white man." Classmate C.A. Towle said, "If I had the choosing of an American army I would choose only such men as 'Rocky' Knight, fearless, honest, clean, and able." (Right, courtesy of Worcester Academy.)

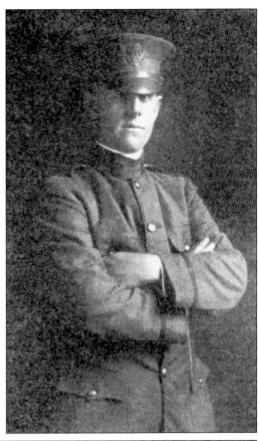

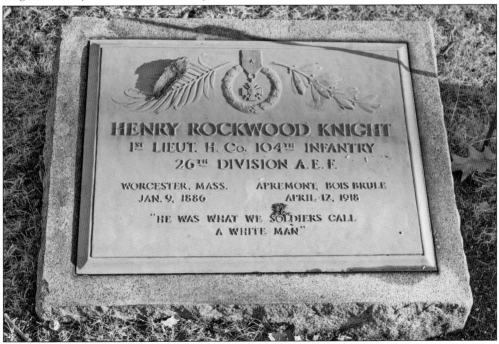

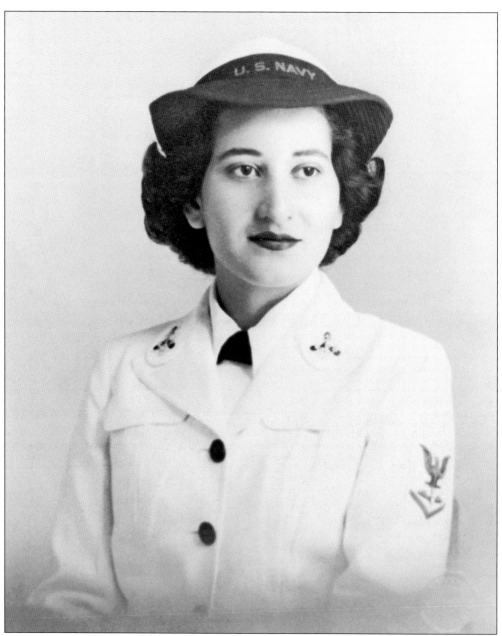

Mary Haroian was born in December 1920 in Illinois, and as a young girl moved to Worcester, where she graduated from Commerce High School and Becker College. She enlisted in the Navy, and served in Florida through World War II. After the war, Haroian enrolled in Clark University, where she obtained a bachelor's and master's degree in psychology. She put those degrees to good use and received her psychologist license and worked for the Travelling School Clinic of Grafton State Hospital, where she traveled to different schools to evaluate children and their problems. In 1951, she married Aram Tashjian and the couple ran Brittan Pharmacy until their retirement in 1988. She began teaching psychology at Quinsigamond Community College in Worcester, retiring at the age of 90 in December 2010. She passed away in June 2015 at the age of 94 and is buried with her husband in Hope Cemetery. (Courtesy of Thomas Tashjian.)

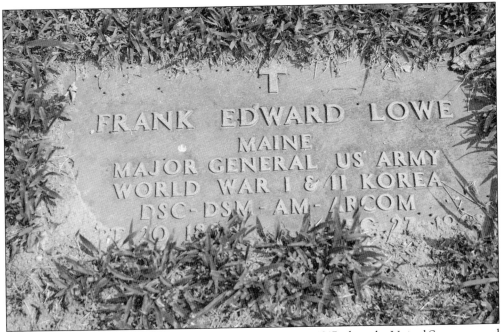

FRANK EDWARD LOWE
MAINE
MAJOR GENERAL US ARMY
WORLD WAR I & II KOREA
DSC · DSM · AM · ARCOM

Frank E. Lowe was a military hero. His Army career began in 1917 when the United States entered World War I. When World War II began, Lowe re-enlisted. But his service was not finished. Pres. Harry Truman promoted him to major general, and he returned to duty during the Korean War. He was President Truman's personal representative on the ground, and received the Distinguished Service Cross for his service.

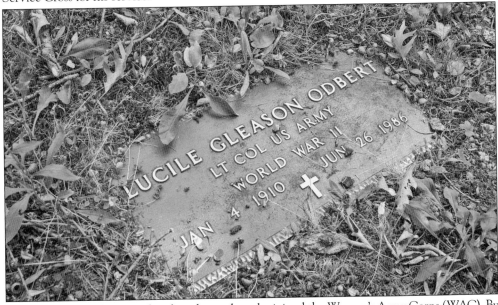

LUCILE GLEASON ODBERT
LT COL US ARMY
WORLD WAR II
JAN 4 1910 JUN 26 1986

Lucile Gleason Odbert was five-foot-three when she joined the Women's Army Corps (WAC). By 1943, she was a second lieutenant and made captain by the end of World War II. But her service was not done. Odbert remained in the WACs, rising to major by 1948. By her retirement in 1963, she had received the WAC Service Medal, the Bronze Star, a World War II Victory Medal, and a National Defense Service Medal.

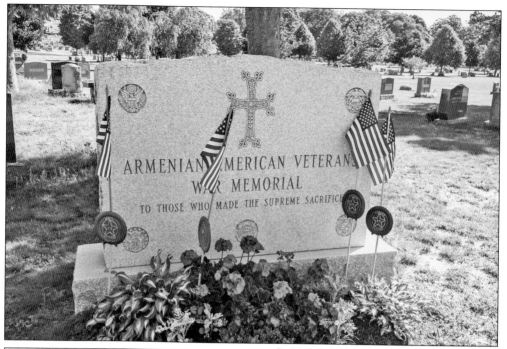

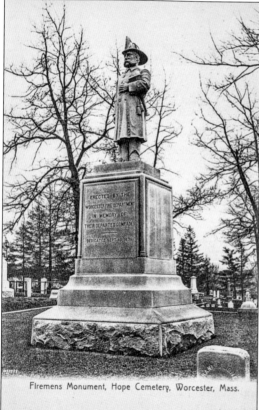

In November 1992, the Armenian American Veterans' Association Inc. of Worcester presided over the dedication of a monument in Hope dedicated to all Armenian Americans who served in the military. In front of the monument are four military grave markers for World War I, World War II, Korea, and Vietnam. Erecting this monument was also the last act of the association, which dissolved shortly after.

Firemens Monument, Hope Cemetery, Worcester, Mass.

Worcester takes its first responders seriously. In 1896, a lot was created to honor the city's fire department. The monument was erected by the Worcester firm of Evans and Company. The figure of Chief Simon Coombs shows him standing, leaning against a hydrant, with the base of the statue edged in the hoses and couplings of the firefighting equipment replicated in Fitzwilliam granite. Chief Coombs is interred in Rural Cemetery. (Courtesy of the American Antiquarian Society.)

Five

THE GREAT, THE GOOD, AND THE NOTORIOUS

INTERESTING LIVES IN THE END

Sometimes ordinary people have extraordinary stories. Worcester is a city of innovation, with science and technology at the forefront even a century ago. But this city also housed politicians and activists, some of whom made national news, and even the occasional murderer. Hope Cemetery is filled with people who have risen from obscurity to make a difference in the city of Worcester. (Courtesy of the American Antiquarian Society.)

Walter Porter was lucky— even though he was lost in the sinking of the *Titanic* in 1912, his body was recovered. "A life belt was about his waist, he having evidently jumped as the great liner took its last plunge, and had then perished in the intensely cold water," *Worcester Magazine* wrote in 1912. "His last letter home was an optimistic one but carried with it a tinge of homesickness." (From the collection of Worcester Historical Museum.)

This was not Porter's first ocean trip. He was nearly shipwrecked in a hurricane sailing off South America when he was only 21. But his next voyage would be his last. Porter was 46 and traveling from Southampton, England, to New York City, when the *Titanic* went down with over 1,200 lost. Porter is buried in his hometown of Worcester. (Courtesy of Tristan L. Hixon.)

One of the most notorious trials of the 1920s was the infamous Sacco and Vanzetti trial. Held in the Norfolk County Superior Court in Dedham, Massachusetts, during the first years of the decade, the two immigrants were accused of taking part in the robbery and killing of the man guarding the pay for a shoe company. Found guilty, the pair were sentenced to death and executed in August 1927. The judge in the case, Webster Thayer of Worcester (right), became a target after the execution. His house was bombed early on the morning of September 27, 1932. None of the family were injured, but the maid was hurt and windows were broken all over the neighborhood. The house had to be demolished. Judge Thayer died of a stroke a few months later and was buried in Hope Cemetery.

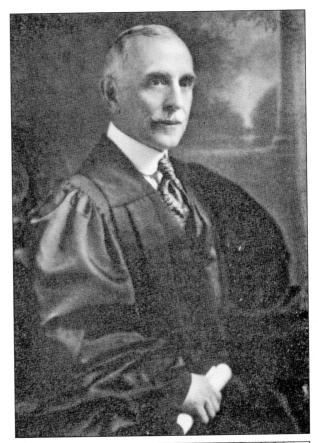

Hannah T. Moore lived an ordinary life. Married to Jonathan Whitney, the couple had six children. Jonathan worked for the railroad as an express driver, and died in a railway accident in 1877. He was reportedly "killed by cars," which sounds quite gruesome, and Hannah became widowed after almost 30 years of marriage. She lived 20 more years, dying on June 4, 1900. The couple are buried in Hope Cemetery.

As a child, Lucy Ann Moore Richardson developed an aptitude for drawing and painting and studied art in New York City and in Florence and Rome, Italy. She also studied with artist Joseph Greenwood. Several of her paintings were collected by local luminaries, including Mrs. C. Goddard and Mrs. Arthur Rockwell. She was well known among Worcester artists for both her own work and her interest in art.

Thomas H. Dodge's claim to fame had little to do with his occupation. Working in the textile industry as a very young man, he invented several improvements to weaving and spinning machines, and in the printing industry, before becoming a lawyer. He had a successful law firm in Washington, DC, but found himself drawn to the "dead letter" branch of the post office. In 1856, Dodge suggested to the postmaster general that dead letters be returned to senders. Strangely enough, many in Congress opposed the move, but public pressure won the day. Dodge moved to Worcester in 1864, later starting the Worcester Barbed Wire Fence Company in 1881 with Charles Washburn. Dodge put his wealth to good use, donating land for Dodge Park on Randolph Road and for the building of the Odd Fellows' home nearby. That building (below) was torn down in 2014.

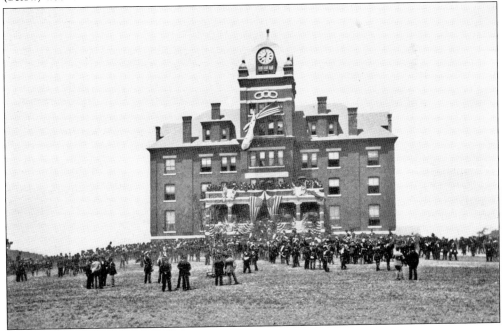

Born in Worcester in 1871, Robert Kendall Shaw is best known as a librarian in the Free Public Library in Worcester. He graduated from Worcester Classical High School in 1890 and went on to graduate *summa cum laude* from Harvard in 1894. He began teaching at the Highland Military Academy in Worcester before working at the New York State Library. He then began work as an assistant at the Library of Congress and returned to Worcester in 1905, working as an assistant librarian at the Free Public Library. Shaw was made head librarian in 1909, and during his tenure, the Greendale, Quinsigamond, and South Worcester branches of the Worcester Public Library were opened. He married Bertha Brown, a native of Wisconsin, in 1902. The pair never had children but traveled several times to Europe. He died in 1956, and his wife followed a year later. They are buried in Hope with his parents.

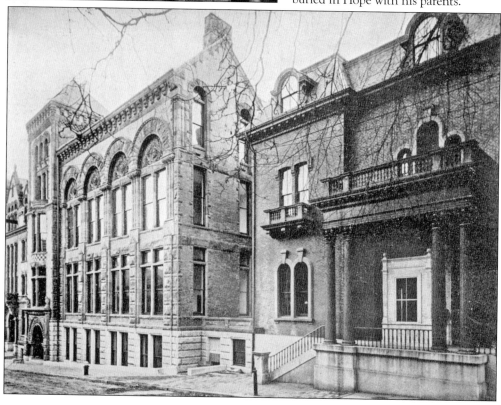

When abolitionist Abby Kelley married abolitionist Stephen Symonds Foster in 1845, the two radicals became the toast of Worcester. Their farm in Tatnuck Square was named Liberty Farm and became a stop on the Underground Railroad. By 1850, Abby began speaking on the women's rights movement, participating in the first National Woman's Rights Convention held in Worcester that fall. One local newspaper jokingly called Stephen the "husband of Abby Kelley Foster." The Fosters continued their progressive views into their older years, refusing to pay taxes on Liberty Farm in protest of Abby not being allowed to vote. Their farm was auctioned several times by the local sheriff; each time their neighbors would buy Liberty Farm and give it back to Abby and Stephen. Their daughter Alla bought their monument at Hope Cemetery and is buried with her parents. (Right, from the collection of Worcester Historical Museum; below, courtesy of Tristan L. Hixon.)

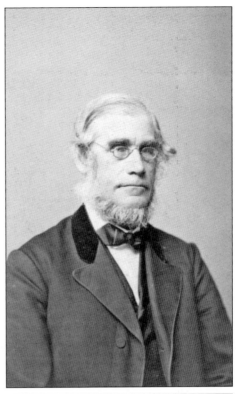

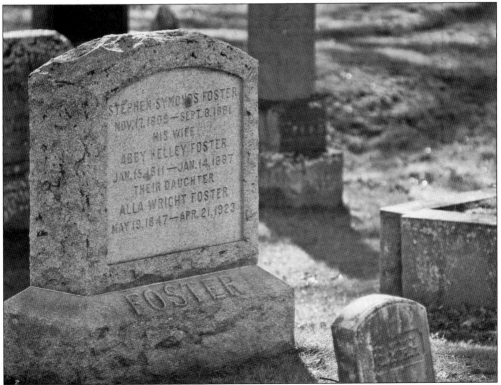

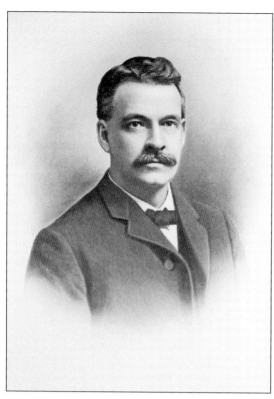

Charles Franklin Stevens invested in Worcester. He attended Howes Business College before getting his degree at Harvard Law School. In 1898, he built an apartment block on Main Street with the latest amenities: incandescent lights, electric bells, speaking tubes, steam heating, modern appliances, and even elevators. Six stories high, the Aurora (below) still stands, with a marble front with four stores on the ground level and a hundred rooms above. Charles Stevens's father, Charles Pardon Stevens, attended Worcester Academy when Eli Thayer was headmaster. The elder Charles headed to California during the gold rush, relocating to Worcester to start a sash, door, and blind business with his brother. The younger Charles married Mary Bradford Gooding of Bristol, Rhode Island. She could trace her ancestors back to the *Mayflower* and was a member of the Daughters of the American Revolution.

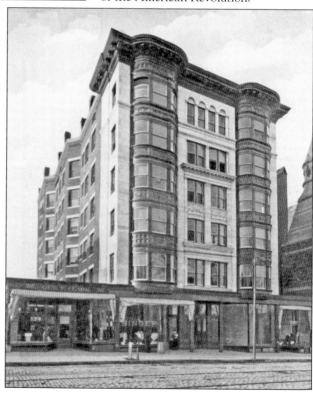

Born in Mendon, Massachusetts, Eli Thayer was an antislavery advocate and teacher. He taught at Worcester Academy, later serving as the school's principal. Thayer also served in local government, including as alderman, on the school committee, as state representative, and eventually as a US congressman. He is remembered for his push to encourage abolitionist settlers to move to Kansas, which helped keep the state from seceding from the Union as the country fell into Civil War. The group he founded, the Emigrant Aid Society, was instrumental in sending thousands west, and towns like Lawrence, Topeka, Boston, and Manhattan, Kansas, all sprang up from his efforts. Thayer also founded one of the first colleges for women in the city of Worcester in 1849, Oread Collegiate Institute, located off South Main Street.

Mary Gibbs Spring was a student at Worcester's Classical High School when her father, Joseph, died, and she had to begin a life of work. Trained at Howes Business College, she became a bookkeeper and was hired by John Francis Bicknell, who was married to her sister. After John died, the sisters decided to continue the business with Mrs. Bicknell as president and Mary as treasurer. This woman-owned business prospered. Mary, who was active in the Universalist church and the treasurer of All Souls Parish, began to acquire property. She had an apartment building constructed in 1898. Called "the Gibbs," the building was located on Main Street. Standing five stories high, this modern brick structure contained 10 finely-finished apartments.

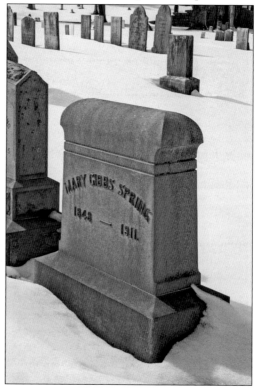

Francis Harrington served as the mayor of Worcester from 1890 to 1892 and also as a state senator. He was born in Worcester in 1846 and attended public schools in the city before attending Howes Business College. He partnered with his brother Charles, who had established the Bay State Livery Stable in 1869. In 1871, the brothers changed the firm name to Harrington Brothers, and in 1882, Charles retired and their brother Daniel took his place. Francis retired from the business in 1895 and invested his time and money into local insurance companies. He married Roxanna Grout in 1871, and they had three children: Charles, Frank, and May Emily. Roxanna died on December 24, 1900, of pneumonia at the age of 50. In 1902, Francis married Lilla Dudley Leighton. Lilla's daughter Leonora married Francis's son Frank in 1900.

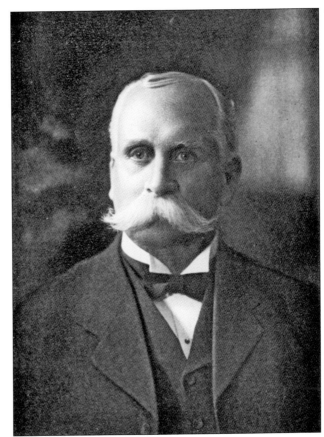

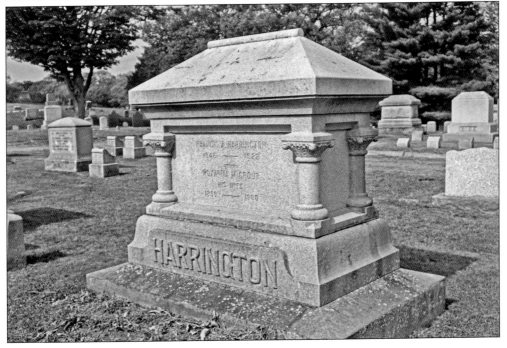

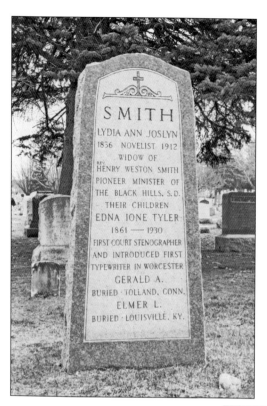

Rev. Henry Weston Smith was a Civil War veteran before moving west to become a minister in Deadwood, South Dakota. After Custer's last stand, Smith was returning from preaching when he was attacked by members of a Sioux tribe. After being shot, he returned fire, killing one of the natives. Dragged from his saddle, hacked, and shot to death, the natives discovered their mistake, realizing they had killed a minister.

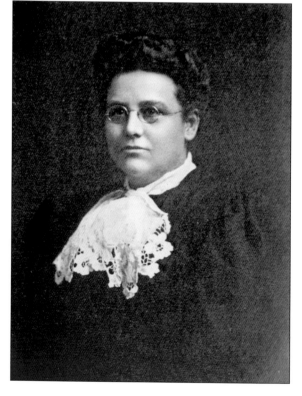

Reverend Smith is not buried in Hope Cemetery, but his death pushed his wife to work to support her three children. Lydia Smith became a writer. Her daughter Edna Ione Smith studied shorthand and typewriting in Worcester; she eventually opened an office as a court reporter and later established a school to teach typewriting and stenography. She became an author, like her mother, and continued working even after marrying Erastus D. Tyler.

Robert Goddard was ahead of his time. Considered the father of modern rocketry, he set off the first liquid-fueled rocket in 1926 and continued to send rockets into the atmosphere, even as others scoffed at his work. Known around town as "Crazy Bob," Goddard reportedly kept a suitcase of TNT in his attic. *The New York Times* ridiculed his work on space travel, words they had to retract after Apollo 8 took off for the moon in 1968. But men of repute recognized his genius—Charles Lindbergh visited his home, where Goddard and his wife, Esther, served him chocolate cake and milk. A Worcester native, Goddard graduated from two colleges in the city: Worcester Polytechnic Institute and Clark University. His early experimentation with rockets took place in Worcester, although Auburn can claim to be the site of the rocket flights. (Right, courtesy of the Auburn Historical Museum; below, courtesy of Tristan L. Hixon.)

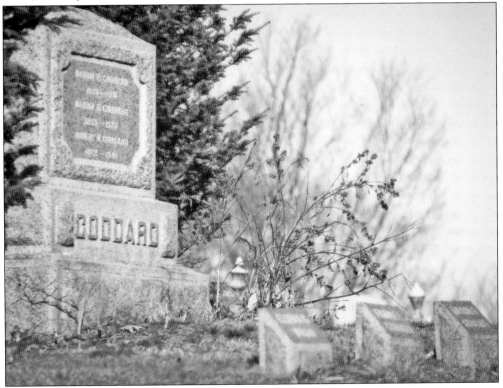

Robert Goddard only filed two patents in his lifetime—one for a rocket that used liquid fuel, and another for a rocket using solid fuel. After his death, his wife received 131 patents in her husband's name, using his notes and drawings to make the applications. A shy woman, she began speaking on her late husband's work, keeping his name alive in the scientific community. (From the collection of Worcester Historical Museum.)

Charles C. Fuller was only 11 years old when his father died in the Civil War. The younger Fuller moved to Worcester, working as a local costume maker. His designs were "notable," according to a front-page story in the *Worcester Telegram* announcing his death in 1910: "For years mask balls in Worcester were much identified by the trappings assembled under his direction. Originality was the keynote of his work." (Courtesy of the Library of Congress.)

Charles C. Fuller fractured his skull falling off a ladder while visiting the Smith farm in nearby Leicester. He suffered a concussion and an eight-inch scalp wound after falling about 15 feet while descending from the hayloft at 2:30 a.m. The newspaper did not elaborate on what Fuller was doing in a hayloft at that time. He died the next day and is buried near his father in Hope Cemetery.

A self-taught young man, Charles Gardner Reed worked in a wheel factory by day and went to evening school, passing the exam to enter high school without even attending the intermediate grades. After his family moved to Worcester in 1849, Reed began a successful business making carriage wheels. He served in city government as a councilman, an alderman, and even the 21st mayor of the city from 1884 to 1885.

"Death is as he wishes!" the *Worcester Telegram* read on November 22, 1899. Charles Gardner Reed, "apparently in perfect health, dropped dead of heart disease" while talking to Samuel Heywood on the corner of Belmont and Orchard Streets, according to the paper. He was carried to the home of James Quigley but died on the man's couch. Reed's funeral was held at Plymouth Church, and his burial was arranged by Sessions & Son in Hope Cemetery.

Charles Tucker was accused of the murder of Mable Page at her home in 1904. The evidence against him was thin. He had an alibi, yet the jury was swayed by the latest in forensic science, and Tucker was convicted in January of the following year. He was condemned to die in the electric chair. The public was outraged, but he was executed in 1906. His grave is unmarked.

Six

FLESH AND STONE

THE CREATORS BEHIND THE BEAUTY OF HOPE

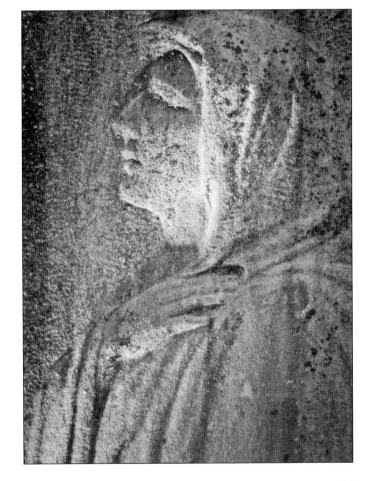

Cemeteries are filled with stone and symbolism. Of course, the landscape—the larger stones, monuments, and mausoleums—are obviously the final resting places of the wealthy, and the more modest markers are those of the ordinary folk. But what of the symbolism of death or the changing landscape of the internment industry? Does death have a fashion? And who are the creators of the external beauty of Hope Cemetery? (Courtesy of Tristan L. Hixon.)

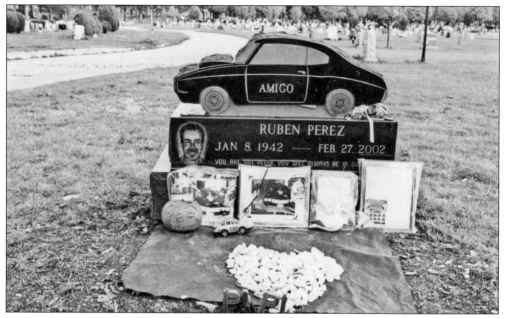

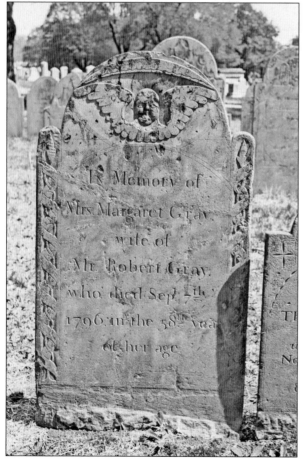

Cemetery styles change. Driving through the center of a New England town, one can tell the age of the local church cemetery just by the style of the stones. Hope Cemetery holds a range of grave markers, from the slate stones of the early settlers of Worcester, which was permanently settled in 1713, to the latest styles with laser etching and gold lettering. (From the collection of Worcester Historical Museum.)

But the symbols in the cemetery have possibly changed the most over time. Early slate stones used the symbols of death—a winged death's head, or a finger pointed heavenward—along with simple symbols like a pinwheel, or natural designs, like simple vines, trees, and floral designs. Because Worcester had been sporadically inhabited until 1722, the oldest designs of slate carving are rare in Hope.

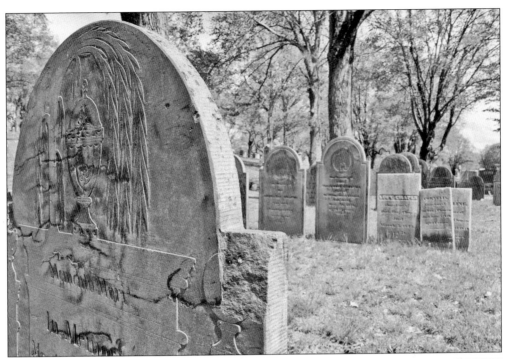

Slate carvings changed after the death of George Washington. The much-revered first president of the United States died on December 14, 1799, leading to nationwide mourning. That in turn led to the use of the urn and weeping willow symbol seen on many slate gravestones carved after 1800. Many of the removal stones brought to Hope Cemetery date from after Washington's death and are carved with that mourning symbol. (Courtesy of Maryanne Hammond.)

Religious symbolism became a distinguishing marker on gravestones, with the cross or Star of David distinguishing the growing religious diversity of the country. Christianity itself has its own encyclopedia of symbols that could grace the gravestone. A look around Hope shows a plethora of symbolism, including the anchor, a symbol of hope; a wreath or palm, symbols for martyrdom; or the obelisk, a symbol for eternal life.

Later, symbols became more personal. The monument became the place to tell the story of the dead, both through words and through symbolism. A stone might contain a symbol for a fraternal order, like Masonry or the Order of Odd Fellows, or the marking of a military order, like the Grand Army of the Republic.

Symbols reflect the taste of the deceased. During the Industrial Revolution, as people began to identify with their craft or skill, those symbols began to infiltrate the cemetery. An arm and hammer might feature on a man's stone, but symbols for women were more complex. This unusual stone, made of soapstone and similar to an early slate headstone, contains a spinning wheel, the symbol of a woman who spun yarn. (Courtesy of Tristan L. Hixon.)

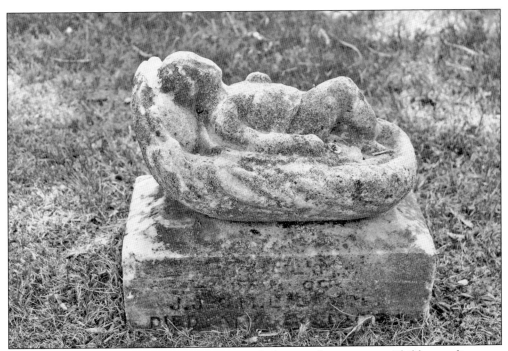

The death of a child also takes on its own symbolism in the cemetery. Child mortality rates around the time of the founding of Hope were high; it was common for a family to bury at least one child, if not more. The symbols of a baby's death could be obvious; some stones include the image of a kneeling or sleeping child, showing the identity of the occupant.

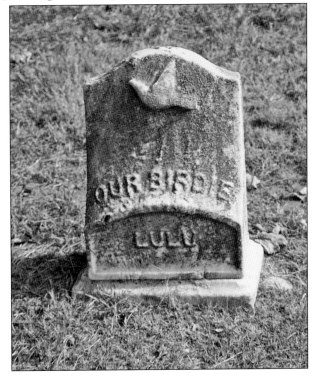

Infant mortality symbolism steeped in religion can be hard to decipher. The symbol for a dead baby could be an angel, cherub, dove, or a daisy, symbols of purity; a rosebud for a young child; or a lamb, a symbol of youth and innocence. Acid rain and years of wear can turn those symbols into simple shapes, but reading the stone can show the information of the lost little ones.

Sayings are also something that began to be included on stones as Worcester became a more prosperous city. Many of those saying are obvious—calls for meeting family members in the beyond, religious sayings, or quotes from scripture. But occasionally, those sayings can be an interesting surprise for the Hope visitor.

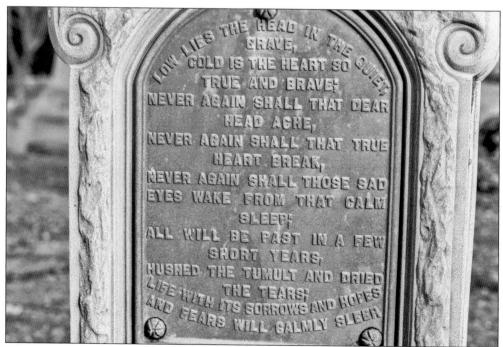

Worcester is a city of education. Even in the early 1900s, Worcester had nine colleges and institutions of higher education. Today, there are 10. Many stones in Hope Cemetery reflect the education of the people buried there, with snippets of poetry from writers like Tennyson engraved on stones or plaques.

The Monumental Bronze Company of Bridgeport, Connecticut, produced "white bronze" markers from 1874 until 1914. They touted the markers as being sturdier than stone and relatively cheap. The general public feared this new "stone" would not stand the test of time; however, a century later, these markers are almost as clear today as when they were cast.

White bronze gravestones are mostly hollow, giving a dull ringing sound when tapped, and have a cold blue or grey coloring that stands out among the marble, granite, and sandstone markers. Rumor has it that the production process helped people circumvent the law during Prohibition. Panels on the monuments are removable, allowing for personalization. But behind the panels is a vacant space, perfect for storing an illicit bottle of alcohol.

WHITE BRONZE
MONUMENTS AND STATUARY.

PLEASE
PRESERVE
THIS
CARD.

MONUMENTAL
WORK
INTERESTS ALL
SOONER OR
LATER.

THE MONUMENTAL BRONZE CO., BRIDGEPORT, CONN.

The stones came in a variety of shapes and sizes and could include standard sayings and symbols, or be custom-made, down to the casting of effigies of the dead. The monuments were meant to look like stone even though they were actually made of an alloy of zinc. Being made of nonporous and fairly corrosion-resistant metal, the stones wore well, almost impervious to acid rain and other elements that can damage stone markers. But zinc can be brittle, and the monuments can crack or tip over time, necessitating repair. (Courtesy of Friends of Hope Cemetery.)

Often startling to modern eyes with their eerie blue hue, white bronze cemetery markers are common in Hope Cemetery. Hope Cemetery has numerous examples of white bronze, like the large cast monument created for the prominent Sloan family, still like new, to simple markers scattered about almost the entirety of the cemetery.

106

The Davis Monument Company created monuments for many of Worcester's up-and-coming families in the mid-1900s. The company no longer exists, but Rex Monuments Inc., which is located across Webster Street from Hope Cemetery, kept photographs of the stones its predecessor created. The conceptual drawing for the Kouri family above shows the process of deciding just what a stone will say. "An epitaph to be selected will be etched here," changes to "Blessed are the pure in heart for they shall see God." The vine and berry carving across the top of the stone, with a Masonic symbol at center, changes in the final version to a grape vine with cross, fringed by an alpha and omega symbol. And in the hand-drawn, pencil-colored version, it is obvious that the stone itself has changed from a pink to a grey granite. (Above, courtesy of the Rex Monument Company Inc.)

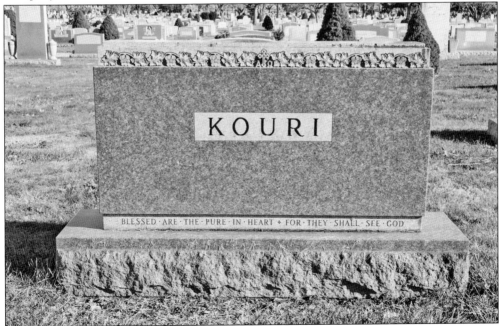

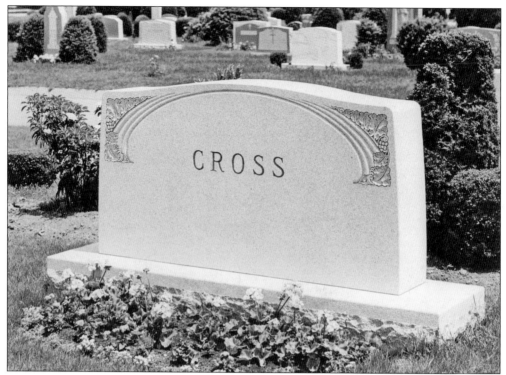

Not only do cemetery styles change, but the cemeteries themselves change. Vintage photographs can also show the evolving landscape of Hope Cemetery. The image above of the Cross monument, put in an area near the front gates not far from the new Hope office, shows a stone that has changed little and a landscape that has changed greatly. The original stone, placed in the 1950s, shows freshly dug soil with evergreens behind and annual plantings in front. The current stone shows a small evergreen behind the stone, yet the other bushes are now gone, replaced with easy-to-mow grass. The annual planting spot in front of the stone has been replaced with perennials, and a nearby tree casts shade over the plot. (Above, courtesy of the Rex Monument Company Inc.)

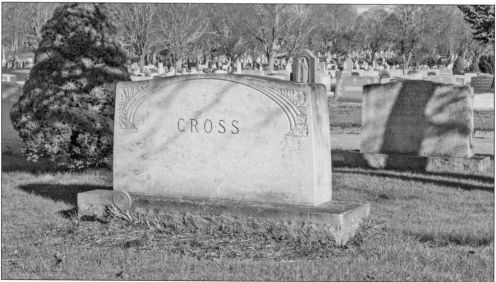

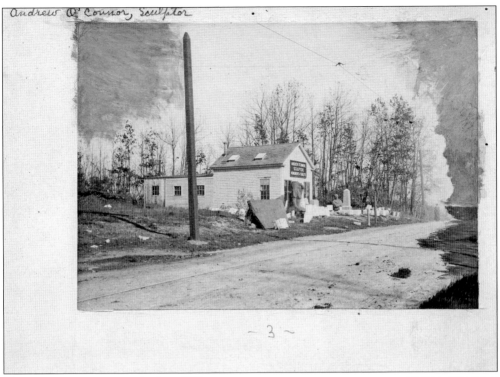

Andrew O'Connor, Sculptor

~ 3 ~

There are two important Andrew O'Connors connected with Hope Cemetery. Andrew O'Connor Jr. designed bronze monuments, doors, and sculptures found world-wide. Andrew O'Connor Sr. gave that love of sculpting to his son, because he was a sculptor himself. Andrew Sr. was born in Larkshire, Scotland, in 1846. The family was living in Ireland at the worst possible moment—the potato blight was about to hit, and starvation would become commonplace. (From the collection of Worcester Historical Museum.)

In 1850, the O'Connor family escaped to Providence, where Andrew O'Connor Sr. learned the sculpting trade. A move to Worcester meant jobs in the marble cutting industry; Worcester was in a growth spurt in 1874, leading to massive building projects. But Andrew Sr. wanted more. He took his family, including young son Andrew Jr., to Florence, Italy, where the elder Andrew learned to draw and model clay. He wanted to be a sculptor.

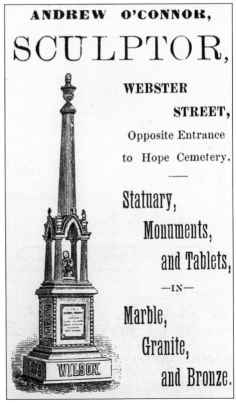

ANDREW O'CONNOR,

SCULPTOR,

WEBSTER STREET,

Opposite Entrance to Hope Cemetery.

Statuary, Monuments, and Tablets,

—IN—

Marble, Granite, and Bronze.

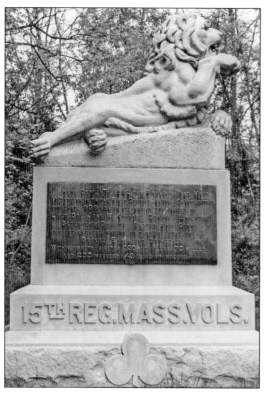

Back in Worcester, Andrew O'Connor Sr. made a name as a sculptor, carving local luminaries like Judge Henry Chapin, the founder of the Worcester Normal School, and Civil War hero Willie Grout. He had nationally important projects, like the sculpting of the wounded lion at the Antietam Civil War battlefield, commemorating the 15th Massachusetts Infantry Regiment. He also sculpted many memorials for important people who were buried in Hope Cemetery. His beautiful monuments include the striking Burnham Wardwell monument, and monuments for several others buried in Hope. However, the locally famous Whittall memorial, featuring angels with a trumpet, has been mistakenly credited to him. Worcester Historical Museum director William Wallace has discovered that the Smith Granite Company of Westerly, Rhode Island, sculpted the monument for the astronomical cost of $6,000. (Left, courtesy of Archives-Museum Branch, the Adjutant General's Office; below, courtesy of Tristan L. Hixon.)

Andrew O'Connor Jr. learned well from his father. Growing up in Worcester, he became a well-respected and acclaimed sculptor and bronze artist, with commissions all over the world. His mother died when he was 14, but he continued his artistic education. He began receiving offers to make public monuments, including bronzes of Abraham Lincoln and an important monument in Worcester to the men who served in the Spanish-American War. (From the collection of Worcester Historical Museum.)

Andrew O'Connor Jr.'s only work in Hope Cemetery celebrated his father's life. He created a funeral monument to Andrew O'Connor Sr. after his death in 1924. The bronze monument, which topped a granite base, was an unusual cruciform with hands. That monument has since been stolen, with only the granite base remaining. Andrew Jr. died in Dublin in 1941 and is not buried in the family plot at Hope Cemetery. (Courtesy of Chapin Library, Williams College.)

111

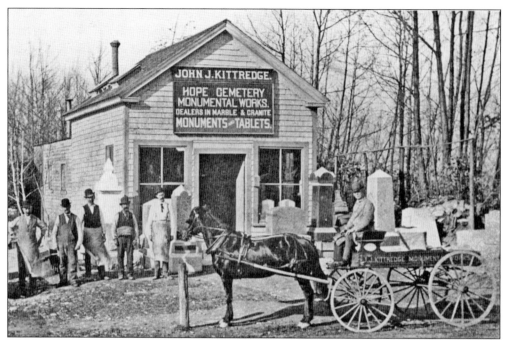

A monuments maker in Worcester, John Kittredge located his business across the street from the Nixon Gates entrance to Hope Cemetery. He was a member of the executive committee of the American Stone Trade. "He is the type of man who throws the full power of his enthusiastic nature into every undertaking that he lays his hand to," a trade magazine reported, noting his "sterling qualities and high ideals." (From the collection of Worcester Historical Museum.)

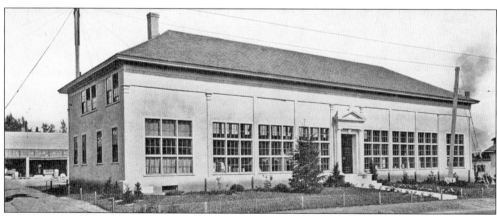

By 1921, John Kittredge was elected president of the Massachusetts Retail Monument Dealers' Association. In fact, there had been a banquet in his honor the year before, and Kittredge was at the height of his trade. He was doing so well, he was able to move from the original building, which had been sculptor Andrew O'Connor's studio, to a new building nearby on Webster Street. That building is still there. (From the collection of Worcester Historical Museum.)

The best part about John Kittredge was that when his daughter Margaret showed interest in the cemetery monuments business, he did not dissuade her. In fact, by 1919 she was planning a trip to the West Coast, where she was to show the latest wares from the Milford Pink Victoria White Granite Company. She was still young, but had spent several years working with her father learning the business. (From the collection of Worcester Historical Museum.)

American Stone Trade gushed about Margaret Kittredge, noting that the business needed an acute understanding of "mechanical process, combined with both art and architecture. For this reason most monument men throw up their hands whenever a woman attempts to associate herself with any part of the business other than the clerical part of it." But Margaret appeared to be a cut above, on a par with most of her male colleagues. (From the collection of Worcester Historical Museum.)

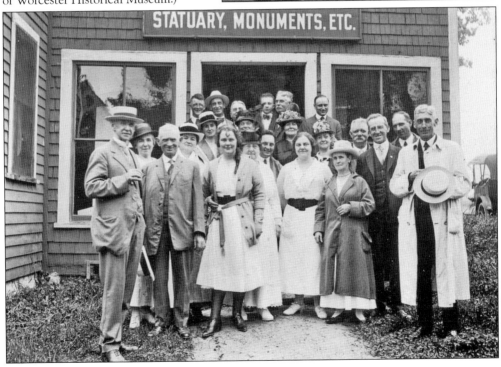

STATUARY, MONUMENTS, ETC.

"By competing salesmen in that territory she is considered, although still in her early twenties, to be a top notcher from the standpoint of salesmanship," *American Stone Trade* noted. "The dealers whom Miss Kittredge will call on will find that she knows the business as well as any man who ever called on them." Margaret and her father worked together for years, and many of their stones are in Hope Cemetery. Margaret Kittredge never married, and when she died in 1989, she was buried in nearby St. John's Cemetery beside her father. Their impact on Hope is in full view of the public. John Kittredge also cut the granite base for the Spencer, Massachusetts, Civil War Soldiers' Monument, with sculptor Andrew O'Connor Sr. involved in casting the figure. John assembled the monument and attended the dedication ceremony on Patriots Day 1911.

Finding information about a forgotten stonecutter whose work graces the resting spots of Hope's residents is almost miraculous, but the staff at the Hope Cemetery office had an old, dark photograph of a stonecutter with a snatch of information on the back. That photograph led to the discovery of Herbert Rundle. (Courtesy of Hope Cemetery.)

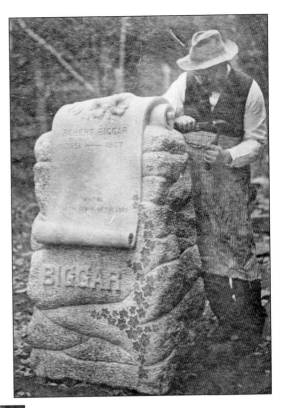

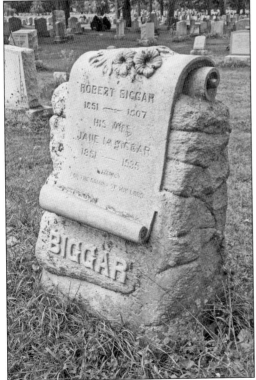

Born in England in 1872, Herbert Rundle immigrated to the United States in 1894 and met his wife, Margaret, who had come to this country from Scotland eight years earlier. By 1904, the family was living in Worcester, and Rundle listed his occupation as stonecutter of "monuments." It is unclear when his photograph was taken, but the stone he created for Robert Biggar and his family was probably carved around 1907.

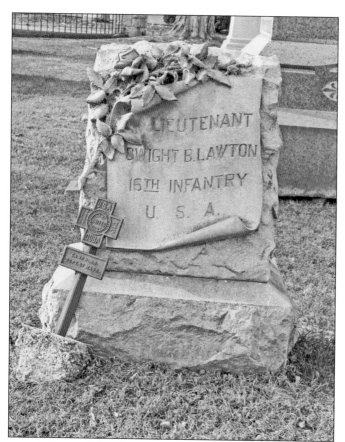

After World War I, Herbert Rundle was working as a machinist in a carpet factory, possibly getting too old for the physical work of stone carving. But walking around Hope Cemetery can lead to the discovery of monuments that look very much like the hand of Rundle was involved, even if his name was almost lost from the history of Hope. He is buried in Hope.

Herbert Rundle died in 1935, but his stone does not reflect the artistry of the man. The stone, a simple red granite, is sited in a diverse section filled with people of all religions and ethnicities and coming from many countries. But the simple stone simply says "Rundle" on the front, with a spray of flowers—not quite the design he would have given his customers.

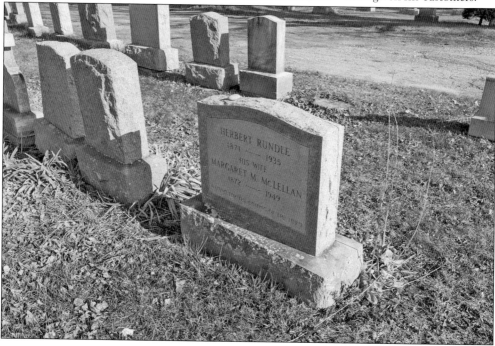

Seven

THE FRIENDS OF HOPE CARE FOR THE FUTURE

PRESERVING A 19TH-CENTURY CEMETERY

By the 1990s, Hope Cemetery had fallen on hard times, with growing concern about upkeep. The Worcester Parks, Recreation and Cemetery Division oversees more than 60 parks and playgrounds along with Hope Cemetery. But the resting place had been on the budgetary chopping block when it came to city politics. This situation just could not stand, not for the loved ones of the interred or for the lovers of the cemetery. (Courtesy of the Friends of Hope Cemetery.)

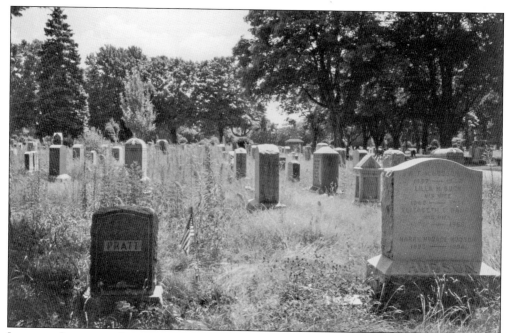

In stepped a group of concerned citizens who wished to assist the city in the preservation, conservation, and beautification of the cemetery. In 1991, the Friends of Hope Cemetery was born when Ann "Cookie" Nelson read too many negative news stories about tall grass and weeds among the headstones and decided to take action. (Courtesy of the Friends of Hope Cemetery.)

Nelson approached Worcester parks commissioner Tom Taylor and found him very supportive of the idea of a group of volunteers helping with cleanup and planting. "He was not threatened by the idea of volunteers helping out with a city property," Nelson noted. She was joined by Worcester Historical Museum director William Wallace, who stepped up as president of the Friends of Hope Cemetery.

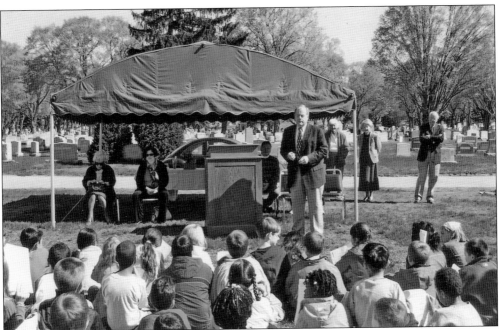

After an initial meeting of about 10 like-minded Hope fans, the newly founded Friends asked Meg Savage to create a logo, which was used in a mailing campaign. Along with Cookie Nelson and Bill Wallace, the original members included Barbara A. Booth, Nason A. Hurowitz, Christos T. Liazos, Kenneth T. Lundquist, Joseph R. Mars, Ardemis Teshoian, and Mario V. Zona. Wallace was elected president and Nelson vice president. (Courtesy of the Friends of Hope Cemetery.)

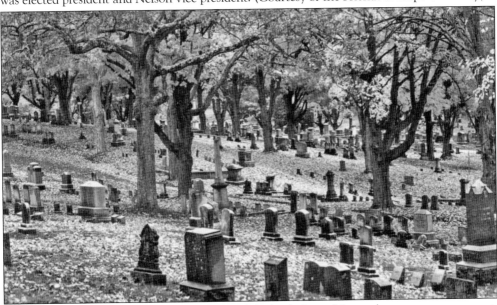

The group also did something wise—they visited the birthplace of the garden cemetery movement, Mount Auburn Cemetery in Cambridge, Massachusetts. When Hope Cemetery was founded in 1854, the grounds were based on the new movement, with Mount Auburn as the pinnacle. "When you want to know what to do, you go to the best of the best," Nelson said. (Courtesy of the Friends of Hope Cemetery.)

The early 2000s brought some city neglect within Hope as budget cuts caused the cemetery to lose half its maintenance staff. The grass and weeds grew, raising the ire of relatives visiting their families' graves. The city commissioned reports on whether the maintenance of the cemetery should be privatized or Hope sold. In fact, that discussion had been raised several times over the recent decades. (Courtesy of the Friends of Hope Cemetery.)

The Friends of Hope Cemetery grew quickly, and the assisting began. One of the first tasks the group took on was simple and contained: they decided to clean up the circular area near the Nixon gates, which had become overgrown. The group did a cleanup, planting a tree and some bulbs. "We were all younger then, and could still get on our knees," Nelson laughed. The tree and many of the bulbs remain. (Courtesy of the Friends of Hope Cemetery.)

As the 1990s continued, the Friends of Hope began the fight to have Hope Cemetery listed in the National Register of Historic Places. The two-year process was painstaking, with extensive research being completed on the important historic monuments and mausoleums in the grounds. "The documentation contained in surveys and nominations of these historic burying places is the key to their better protection and management," the *National Register Bulletin* notes. (Courtesy of Tristan L. Hixon.)

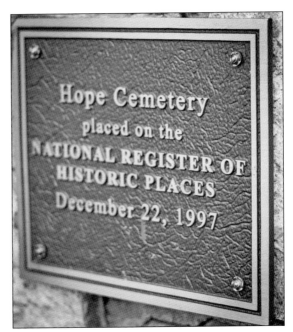

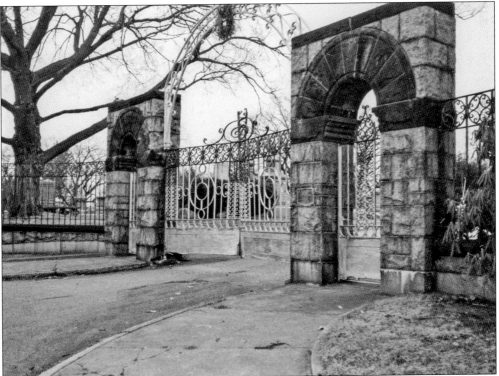

A chance meeting between members of the Friends of Hope and a descendant of the Houghton family, who came from California to look into repairs for his family's crypt, led the group to think about larger projects. That, of course, would mean a larger budget. The Friends of Hope started a capital campaign and began the 1995 restoration of the Nixon gates, which front Webster Street and had fallen into disrepair. (Courtesy of the Friends of Hope Cemetery.)

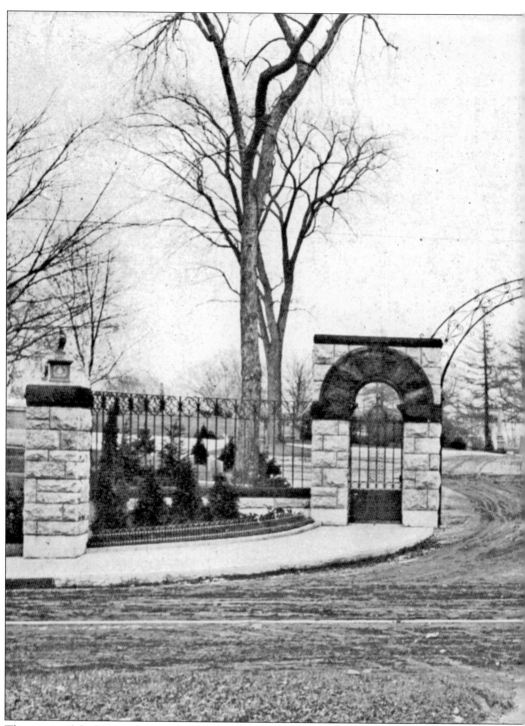

The repair of the Nixon gates and the National Register listing gave the Friends of Hope some cachet and a bit of clout when it came to raising funds. Not only did the group have publicity, but the National Register designation opened the door to grants and funds from groups like the Massachusetts Historical Commission. But the Friends of Hope were far from done. Inclusion on

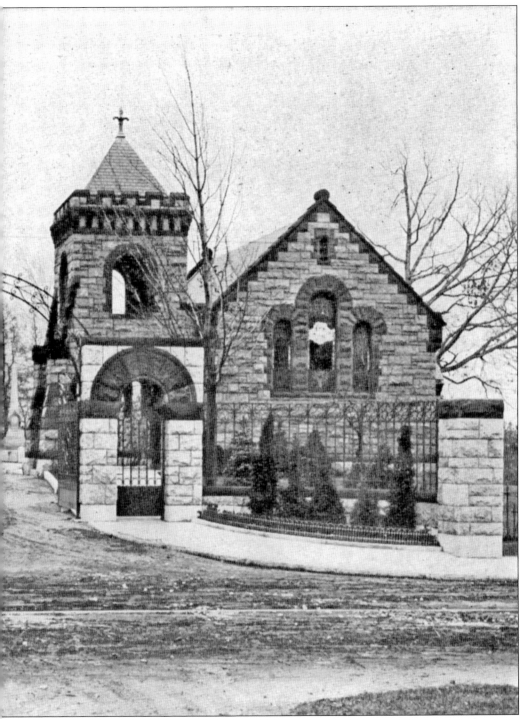

the register did not negate the fact that several of the monuments inside Hope were in desperate need of repair. In 2002, the Friends sought grants to save the "beehive" mausoleum of builder James Norcross from further decay. This mausoleum is considered one of the most beautiful of the many mausoleums in Hope. (From the collection of Worcester Historical Museum.)

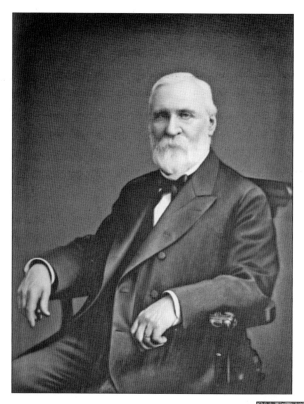

The Norcross brothers were revered in their time as builders to the best architects of the late 1800s. The men built all over Worcester, including City Hall, the Worcester Art Museum, and Classical High School. Nationally, they were the builders behind architects like H.H. Richardson and his masterpiece, Trinity Church in Boston, among other great buildings nationwide. James Norcross's mausoleum is a masterpiece of the best materials and building practices.

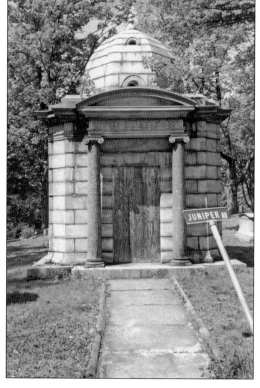

The beautiful mausoleum had fallen into disrepair, including the loss of beautiful bronze doors, which had been stolen. Because the mausoleum is privately owned by the family, the Friends of Hope convinced a Norcross descendant to sign the deed over to the group. They then applied for and secured a grant from the Massachusetts Historical Commission to help pay for part of the costs, and paid for the rest of the project themselves. (Courtesy of the Friends of Hope Cemetery.)

James Norcross's brother Orlando was an important partner in the firm and the engineering genius. He is also buried in Hope, but under a Greek-inspired temple in another section. Hope is estimated to currently hold well over 70,000, although early records were not perfect. With future expansion, the master plan for Hope looks forward to another 150 years of burials and cremations.

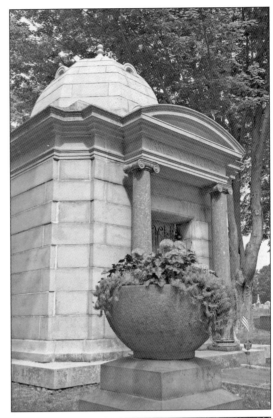

After the Norcross project, the Friends of Hope began yet another capital campaign, this one to erect a Children's Monument near the new Hope office building. Children are an important part of the education programs of the Friends of Hope. "We want children to see the cemetery in a happy time, so that if they're ever there for a sad event they will remember happier times," Nelson noted. (Courtesy of the Friends of Hope Cemetery.)

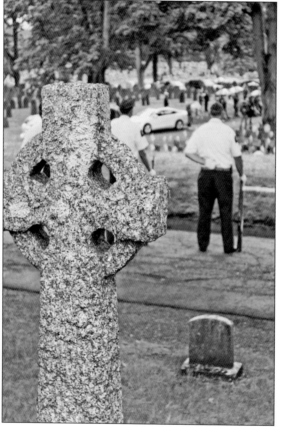

In some ways, Hope Cemetery has returned to its original purpose, beyond just being a place for the burial of the dead to become a place for contemplation and recreation. The Friends of Hope promote the cemetery through community outreach programs offered throughout the year, including lectures, walking tours, Arbor Day activities, and bird-watching tours. The group has held photography contests and sold calendars of photographs taken by the winners.

There are also plenty of American flags to get ready for the annual Memorial Day celebrations. A Memorial Day program happens yearly, and the Friends of Hope remain an important part of Hope Cemetery. The group stepped up when a new water system was needed in the cemetery, raising half of the $500,000 cost. "This little, tiny nonprofit organization raised a quarter of a million dollars," Nelson told *Worcester Magazine*.

ABOUT THE FRIENDS OF
HOPE CEMETERY

The Friends of Hope Cemetery was founded in 1991 by a group of concerned citizens who wished to assist the city in the preservation, conservation, and beautification of the cemetery. The Friends promote an appreciation of the cemetery with a wide variety of programs including historical walking tours, lectures, bird walks, clean-up days, conservation workshops, and Arbor Day activities.

The Friends have taken on several significant preservation projects over the decades. Those projects included the restoration of the Nixon gates, which face Webster Street and have become a symbol of Hope Cemetery. The group also became the owner of the James Norcross "beehive" mausoleum, and has raised funds for the reconstruction of the historical landmark, which had fallen into disrepair.

The Friends of Hope Cemetery have also partnered on the restoration or conservation of several other large monuments, including the Shaw mausoleum, the Orlando Norcross mausoleum, and the Bigelow/Stevens mausoleum. The group took on the task of cleaning and repairing the fencing and gate of the Coes family plot.

In 2004, a capital campaign was launched in partnership with the city to erect a children's monument and to design accompanying landscaping. Even more recently, the Friends raised $250,000 to help repair the deteriorating water system at Hope, which was about half the cost of the project. The City of Worcester picked up the remaining cost of the infrastructure repair. "There was some feeling this might be impossible because we're a tiny grass-roots organization, but with the great leadership of Val Loring, our campaign chair, we were able to raise $250,000," Ann "Cookie" Nelson told the *Worcester Telegram & Gazette* in 2015.

Through the advocacy of the Friends, Hope Cemetery was listed in the National Register of Historic Places in 1998. This nonprofit organization welcomes all persons interested in the welfare of the cemetery to become a member of the Friends Hope Cemetery. For more information, please visit the Friends of Hope website at www.friendsofhopecemetery.com.

DISCOVER THOUSANDS OF LOCAL HISTORY BOOKS FEATURING MILLIONS OF VINTAGE IMAGES

Arcadia Publishing, the leading local history publisher in the United States, is committed to making history accessible and meaningful through publishing books that celebrate and preserve the heritage of America's people and places.

Find more books like this at
www.arcadiapublishing.com

Search for your hometown history, your old stomping grounds, and even your favorite sports team.

Consistent with our mission to preserve history on a local level, this book was printed in South Carolina on American-made paper and manufactured entirely in the United States. Products carrying the accredited Forest Stewardship Council (FSC) label are printed on 100 percent FSC-certified paper.

MADE IN THE USA